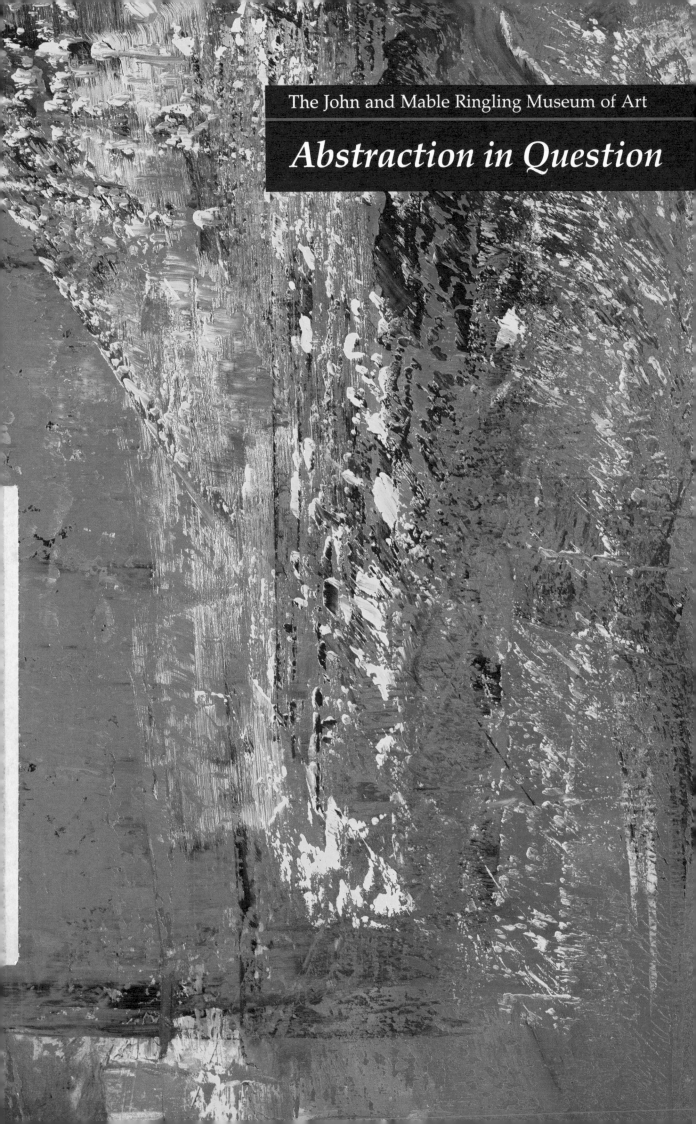

The John and Mable Ringling Museum of Art

Abstraction in Question

CONTEMPORARY PERSPECTIVES 1

Abstraction in Question

An Exhibition of
The John and Mable Ringling Museum of Art

Organized by Joseph Jacobs, Curator of Modern Art
The John and Mable Ringling Museum of Art

Exhibition curated and essays written by
Bruce Ferguson, Joan Simon, and Roberta Smith

The John and Mable Ringling Museum of Art, Sarasota, Florida
January 20-April 2, 1989

Center for the Fine Arts, Miami, Florida
May 20-July 23, 1989

*This project was supported in part by a grant from the
National Endowment for the Arts, a Federal agency.
Additional funds were provided by the Mellon Foundation,
The John E. Galvin Charitable Trust, and contributions to
The John and Mable Ringling Museum of Art Foundation.*

Library of Congress Catalog Card Number 89-80132
ISBN 0-916758-26-5

©1989 by
The John and Mable Ringling Museum of Art Foundation, Inc.
5401 Bay Shore Road
Sarasota, Florida 34243

The John and Mable Ringling Museum of Art Foundation is a private,
fully incorporated non-profit entity established to develop funds to
support the programs, staff, and activities of the Museum.

Editors:	Jon Merlyn, Sarasota, Florida
	Kathleen Chilson, The John and Mable Ringling
	Museum of Art, Sarasota, Florida
Designer:	Michael Hamlin
	Graphics Design Center, Inc.
	Sarasota, Florida
Printer:	Arcade Lithographing Corporation, Sarasota, Florida
Cover:	**Gerhard Richter**
	Still, 1986 (detail)
	Oil on canvas
	88 1/2 x 78 3/4"
	Collection of Raymond J. Learsy, Sharon, Connecticut

Photo Credits
Jon Abbott, New York, fig. 1
Mr. and Mrs. Sydney Adler, Sarasota, Florida, pl. 7
Howard Agriesti, The John and Mable Ringling Museum of Art, Sarasota,
 Florida, pls. 5, 6, 11, 18, 21, 22, 23, 26, 30, 32, 35, 44; fig. 9
Josh Baer Gallery, New York, pl. 25
Mary Boone Gallery, New York, pl. 4; fig. 12
Leo Castelli Gallery, New York, pls. 1, 2, 3, 24, 27
Sarah Charlesworth, New York, pl. 10
Paula Cooper Gallery, New York, pls. 17, 28, 29
D. James Dee, New York, pls. 17, 28
Dia Art Foundation, New York, fig. 1
eeva-inkeri, New York, pl. 29
Allan Finkelman, New York, fig. 2
Barbara Gladstone Gallery, New York, pls. 42, 43
Marian Goodman Gallery, New York, pls. 12, 33
Jay Gorney Modern Art, New York, pls. 8, 9, 37; fig. 13
Pat Hearn Gallery, New York, pls. 38, 39, 40, 41; fig. 6
Hente Photography, Sarasota, Florida, pl. 7
Bill Jacobson, New York, pl. 12
David Lubarsky, New York, fig. 13
Luhring Augustine Gallery, New York, pls. 48, 49
Douglas M. Parker Studio, Los Angeles, pl. 8
Philips/Schwab, New York, pl. 39
Postmasters Gallery, New York, pls. 15, 16, 45; fig. 16
David Reger, New York, pl. 42
Robert Ryman, New York, fig. 2
Holly Solomon Gallery, New York, pl. 31
Sonnabend Gallery, New York, pls. 13, 14, 19, 20, 46, 47
Emily and Jerry Spiegel Collection, Kings Point, New York, pl. 34
Stux Gallery, New York, pl. 36
Grant Taylor, New York, pl. 13
Dorothy Zeidman, New York, pls. 1, 2
Zindman/Fremont, New York, pl. 24

LENDERS TO THE EXHIBITION

Mr. and Mrs. Sydney Adler

Jennifer Bartlett

Norman and Irma Braman

Peter Brams

Leo Castelli Gallery, New York

Elaine and Werner Dannheisser

Edward R. Downe, Jr.

Fried, Frank, Harris, Shriver & Jacobson, New York

Josh Baer Gallery, New York

Barbara Gladstone Gallery, New York

Arthur and Carol Goldberg

Marian Goodman Gallery, New York

Jay Gorney Modern Art, New York

Antonio Homem

Ellen and Ellis Kern

Marvin and Alvin Kosmin

Raymond J. Learsy

Luhring Augustine Gallery, New York

Linda and Harry Macklowe

Anne and Martin Z. Margulies

Joseph E. McHugh

Carol and Paul Meringoff

Metro Pictures, New York

Henry Newman

Richard and Lois Plehn

Postmasters Gallery, New York

The John and Mable Ringling Museum of Art

Randolfo Rocha

Colombe and Leonard Rosenberg

Donald and Mera Rubell

Eric Rudin

Michael Schwartz

Tony Shafrazi Gallery, New York

Holly Solomon Gallery, New York

Sonnabend Gallery, New York

Mr. and Mrs. Robert Sosnick

Emily and Jerry Spiegel

Stux Gallery, New York

University of South Florida, Courtesy USF Art Museum

Elisabeth and Ealan Wingate

Christopher Wool

TABLE OF CONTENTS

PREFACE

While the Museum continues to develop its already prestigious holdings of Old Master paintings, our goal is also to build a significant collection of modern art and vibrant modern art programs that direct attention to contemporary art. *Contemporary Perspectives* is the Museum's third exhibition series focusing on contemporary art to be introduced in the last two years. The other two series are *Projects* and *Featuring Florida*. The former are small-scaled exhibitions that highlight influential emerging artists or established artists producing work that is particularly vital to major issues in contemporary art. *Featuring Florida* is an annual show of two to four artists designed to identify some of the best work being made in the state. *Contemporary Perspectives* is meant to function as a kind of annual or biennial, but one with a strong focus, and an historical perspective. The Museum selects a theme that turns on a problem especially vital for contemporary art; guest curators independently or in conjunction with the Museum's curator debate the issue through the selection of artists and work, and in catalogue essays.

The inaugural exhibition for the *Contemporary Perspectives* series, *Abstraction in Question*, has met all of our expectations. The selected issue examines the status of abstraction: Is it still vital, and thus valid? If so, what is the best work being produced? What form of abstraction is specific to the 1980s? Joseph Jacobs, the Museum's Curator of Modern Art, posed these questions and guest curators Bruce Ferguson, Joan Simon, and Roberta Smith, in their selections and with their essays, have explored them. By including works by Richard Artschwager, John Chamberlain, Roy Lichtenstein, and Gerhard Richter, *Abstraction in Question* provides an important historical component. The show is informative and provocative, and defines the forum for discussion and debate that the *Contemporary Perspectives* series was designed to offer.

I would like to extend my appreciation to the curators for the especially fine job that they have done for this inaugural exhibition. Special thanks go to the many lenders who parted with their work for an extended period and thus made the exhibition possible. I am grateful to the individuals, foundations, and agencies that made this show possible. I especially thank the National Endowment for the Arts, the Mellon Foundation, and The John E. Galvin Charitable Trust, which have supported this exhibition through major contributions to the Museum's Foundation.

Laurence J. Ruggiero
Director

FOREWORD

When Joe Jacobs, Curator of Modern Art at The John and Mable Ringling Museum of Art, proposed the idea of a survey exhibition focused on a single critical issue—abstraction—to be developed by three independent curators/critics expressing diverse points of views he seemed to be offering conditions and a context that are rare in American museums today. The criteria for shaping the exhibition were open to discussion, and the entire project was to be developed in less than a year.

Bruce Ferguson, Roberta Smith, and I began our talks with questions: What conditions, broadly defined, were causing contemporary artists—and not just the youngest generation, though indeed those called "Neo Geo" had boldly brought attention to the subject—to use abstraction? What, if anything, was different about this abstraction, in content as well as in form from a century's worth of art works that have been called abstract (or abstracted or abstracting), and that, with the exception of the pared down, primary object status of Minimal art, have always referred in varying degrees to a host of sources and references—whether they be spiritual, political, mathematical, architectural, organic, narrative, figurative, and so on.

Based on our observations of a variety of art works and limiting our time frame to the past twenty years, we agreed to concentrate on artists who deliberately use abstraction as but one element among several within a particular work of art. As Roberta Smith put it, "*Abstraction in Question* looks at works of art that do not take abstraction for granted."

We also agreed that the exhibition would be exploratory rather than summary. Each of the three guest curators recommended works of art to be included in the show. Though from the outset there was often a consensus, there was an agreement to disagree and an understanding among the curators that the exhibition was to be both reportorial and critical. Rather than settling for acceptable compromises, if one curator felt strongly about an artist's approach or a particular art work's inclusion, it was included. Given the budget (which precluded shipping works from Europe) and space limitations, we were prepared to select approximately twenty artists to be represented by one to four works each.

For viewers of the exhibition, we hope it will be apparent that within these diverse combines of painting/sculpture/relief/found object/photography, two or more methods, materials, and/or ways of thinking are conjoined. In a few cases it will be arguable—or at least not immediately apparent—that these pieces are abstract at all. Rather than eliminating the questions we have focused on them, therefore the title *Abstraction in Question*. It is also hoped that we have let the art works speak for themselves, and that within the individual essays, some of the salient critical and historical issues are illuminated.

Joan Simon
New York, New York

7

INTRODUCTION & ACKNOWLEDGMENTS

Abstraction in Question was conceived in late 1986 and curated by Bruce Ferguson, Joan Simon, and Roberta Smith in early 1987. Despite the two-year gap from conception to installation, which would allow for significant reevaluation of who and what are significant, the original selection of artists and works has held up admirably. The selected *themes* have also held up admirably.

Perhaps the most salient aspect of the show is the fact that much of the work in *Abstraction in Question* is *not* so abstract. As a matter of fact, there are instances when it could be argued that the work is downright representational, as in the case of the paintings of Gerhard Richter and Roy Lichtenstein, the photographs of Sarah Charlesworth, and the sculpture of Haim Steinbach and Tony Cragg. In these instances, the abstract coexists with the figurative, but not necessarily as its handmaiden, as for example in the representational painting of Matisse, Klee, or Miro. The abstract component has a life all its own. In many of the works, its independent identity reflects the artist's preoccupation with abstraction as subject matter—with its history and how it functions within the entire language system of art, in particular with how it functions in opposition to its supposed nemesis, figuration. The painting and sculpture of Richard Artschwager and Roy Lichtenstein, both in this show, not only anticipated in the early 1960s what was to become a preoccupation of the 1980s, but because of the succinctness of their statement, it epitomized it.

More important than just parsing the structure of art, much of the "representational" art in this exhibition signals the end of a belief in abstraction as a system that is superior to figuration; instead artists now recognize it as part of the same signing system that includes figuration, as Bruce Ferguson discusses in his essay. Richter's or Lichtenstein's shifting from figuration to abstraction (or sometimes what only *appears* to be abstraction), from one painting to the next, reflects this realization. Representation figures prominently in *Abstraction in Question* because abstraction is not the religion it once was; artists do not adhere to it with the blind faith they once did. The demise of abstraction-as-religion cannot simply be attributed to the reductivist art of the 1960s, which supposedly stripped painting and sculpture to its essence and disallowed further development. More at issue is the evolution since the late 1960s of a new aesthetic vocabulary, much of which is based on Continental thought; this new vocabulary has increasingly pushed abstraction from center stage to the peripheries. As a result, abstraction is no longer *the* issue. It exists, but its significance is predicated on other, larger issues.

The representational component in much of the work in this exhibition reflects abstraction's change in status: it is no longer *fundamental* to the language used to discuss vital issues in art. This condition—rather than the position that abstract art is no longer pure—stands out as the major contribution of the exhibition. The exhibition is also unique because of the mix of artists and the range of issues covered; Diana Formisano, Andres Serrano, and Wallace & Donohue are presented in meaningful juxtaposition with John Chamberlain, Elizabeth Murray, and Roy Lichtenstein. In terms of reportage, the show is remarkably extensive, including twenty artists represented by fifty works. As important, the exhibition has an historical dimension that firmly establishes the roots for many issues vital to the 1980s in the 1960s.

I would like to extend greatest appreciation to Bruce Ferguson, Joan Simon, and Roberta Smith for producing an exceptional exhibition, one which sets the highest standards for the series it launches—*Contemporary Perspectives*. I would also like to thank the many lenders and artists for participating in the show and, in many instances, for providing invaluable assistance. I would also like to acknowledge many others who were especially helpful: Heidi Anderson, Richard Armstrong, Stefano Basilico, Lawrence Beck, Mary Boone, Paula Cooper, Jessica Cusick, Gus Fabens, Barbara Gladstone, Garry Garrels, David Goldsmith, Julie Graham, Tim Guest, Frasher Hudson, Holly Hughes, Patricia Koch, Elizabeth Kujawski, Elizabeth Kully, Vanessa S. Lynn, Mary Jo Marks, Sarah McFadden, Laura B. Perrotti, Laura Paulson, Janelle Reiring, Gabriella T. Ranelli, Arthur Roger, Magdelana Sawon, Nick Sheidy, Natasha Sigmun, Carl Stigliano, Jill Sussman-Walla, and Helene Winer. I would also like to thank Robert Frankel, Director of the Center for the Fine Arts in Miami, and the Center's Curator of Exhibitions, Mark Ormond, for presenting the exhibition after it closes at The John and Mable Ringling Museum of Art—and for sharing our commitment to bring the finest contemporary art to Florida.

I greatly appreciate the timely and thorough work of Jon Merlyn, who initially edited the catalogue. Sincere thanks go to Elizabeth Telford, the Museum's Exhibition Coordinator, for arranging packing and shipping. I am especially indebted to her assistant, Colleen Burkhart, who did not let a single detail of the exhibition slip through the cracks and who, along with Curatorial Assistant Gina Pesano and Museum Editor Kathleen Chilson, played a major role in the production of the catalogue. Lastly, I would like to thank Jan Silberstein and Elizabeth Namack, two volunteers for the Curatorial Department, for their assistance in various aspects of the exhibition.

Joseph Jacobs
Curator of Modern Art

Abstraction in Question

THAT WAS THEN, THIS IS NOW

By Roberta Smith

Abstraction, the flagship of modern art, is not what it used to be. It is no longer the vessel of purity and reduction that it so often was during the first half of this century. It has become worldly and sometimes wise, self-conscious, and overtly communicative. Its earlier penchant for strict self-reference has been turned inside out to accommodate a multi-referentiality that is freighted with the images, meanings, and materials of everyday life and culture.

What might be called abstraction's pure phase started with the art of the Cubists, Malevich and Mondrian, and reached its apotheosis in the leanly configured canvases of Barnett Newman, Mark Rothko, and the young Frank Stella. Yet, even as this apotheosis was being reached at mid-century, abstraction began to be systematically infiltrated, buffeted by seas of change. Over the past thirty years, a welter of outside influences have penetrated its hull and it has emerged in the second half of the century substantially corrupted and altered, sometimes beyond recognition.

The corruption of abstraction began in earnest in the 1950s with the generation of American and European artists that followed the Abstract Expressionists. This generation included most prominently Jasper Johns, Robert Rauschenberg, Cy Twombly, Joseph Beuys, Jannis Kounellis, and Yves Klein. Reintroducing found materials and images, literature, and symbols into the discourse of abstraction, these artists reversed its tendency toward narrowness. They initiated a period of expansion that, despite some temporary setbacks, is still very much in force.

The expansion and reformation of abstraction is the focus of the exhibition *Abstraction in Question*. This subject is large and encompasses, in one way or another, a great deal of recent art practice. In fact, it would probably be possible to organize a few versions of this exhibition, each with a substantially different list of American and European participants. There are any number of artists—from Stella to Meyer Vaisman—who could easily have been included here, but there was an attempt to avoid predictable choices or overly familiar combinations of artists. There was at least one artist—Robert Ryman—whose work could not be borrowed, and some little-known enamel-on-metal paintings from

the mid-1960s by John Chamberlain (see fig. 1)—relevant to the renewed interest in both geometry and industrial fabrication—that have become too fragile to travel.

The artists selected for *Abstraction in Question* form a deliberately diverse group that may not seem, upon first encounter, obviously cohesive. Rather, the show attempts to define a number of the perimeters of the broad field of current abstract practice. It is a cross section or a representative sampling that touches on several generations of art making.

Starting with a few artists who first made their presences felt in the late 1950s and early 1960s, *Abstraction in Question* also includes others who emerged in the 1970s. But it concentrates on artists who have come to the fore in the 1980s. The show's paintings run the gamut in style—from the extravagantly gestural to the severely geometric—and in fabrication techniques, too. Many artists present make paintings the "old-fashioned" way—that is, by hand and usually with paint and canvas. But there are others whose work relies on mechanical means of one sort or another, or employs store-bought objects or hardware. In addition, artists who broach abstraction in three dimensions and in the medium of photography are also represented.

Despite their differences, however, the artists in this exhibition are united by a desire to speak to the viewer with a directness, and with a legibility, that has not always been a goal of abstract art. In this, their efforts may reflect the fact that in some ways, recent abstract art has come full circle—back to its roots and to the unfinished business of early abstraction.

In the early years of this century, the very word abstraction implied "abstracted from" something else; in other words, from an exterior reference or source. As the images of artists from Kandinsky or Leger to Stuart Davis suggest, abstraction was initially derived from the real world, whether natural or man-made. In their work there was a sense of what might be called social obligation: a feeling that abstraction reflected what was new and urgent, whether in science, philosophy, or popular culture. Kandinsky's early forays into point and line paralleled the development of atomic physics. Davis took inspiration from jazz and later from television—Leger from the machine.

During the heyday of formalist abstraction, this connection was often eliminated. Especially in the years when the New York School was dominant, abstract art tended to aim for great moral fiber and an inspiring level of "content," and was often successful in this quest. But it developed a disdain for "subject matter," or the messy business of being about anything beyond itself, and this tendency was taken even further by Minimal Art. "What you see is what you see," said Stella of his early black stripe paintings. While Donald Judd—asserting that his Minimalist structures were not abstracted *from* anything, and impatient with the traditional connotations carried by the words "painting" and "sculpture"—coined the phrase "specific objects."

In recent years things have changed. While the lessons of Stella and Judd are still pertinent, the bonds between abstract art and the world around it have been rejoined. As much of the work in this exhibition demonstrates, subject matter has been put on a new equal footing with form; abstraction and narrative are no longer seen as mutually exclusive. This is not surprising. For one thing, abstraction itself is now part of our reality, both as a form with its own history and as a visual vocabulary pervasive in the world at large, from corporate logos to video games. In addition, after more than a decade in which subject matter flourished in other areas of aesthetic activity—Conceptual Art and Neo-Expressionism most prominently—it is understandable that repercussions would be felt in abstract art as well.

In a sense, abstraction was under fairly constant attack from 1970 until the mid-1980s. It was threatened by Conceptual Art's emphasis on pure, often linguistic meaning, by the mixed media extravagances of Pattern & Decoration and by the furtive narratives of New Image Painting. Its most serious setback came in the early 1980s with the dominance of Neo-Expressionism. During these years, "the return of the figure" was an often-heard phrase and it seemed that in some ways painting, sculpture, and photography alike were rolling back the "progress" made by abstract art.

But all these tendencies, different as they were, were making much needed progress of their own in the area of meaning, more than form. Together they raised art's consciousness on any number of fronts: political, social, psychological, and historical, as well as in terms of popular culture. They expanded contemporary art's ability to be relevant and self-aware, to tell stories and to reflect, and to reflect upon the surrounding world in many and

Fig. 1

John Chamberlain

Conrad, 1964

Chromium plated steel, auto lacquer

and metalflake on Formica

67 x 67 x 4 3/4 in.

Dia Art Foundation, New York

different ways.

None of these lessons seem to have been lost on abstract art; they were in fact being carefully absorbed. Starting sometime in the early 1980s, abstraction began to show signs of resurgence, but it wasn't quite the same.

Today it may even be possible to speak of abstract art as being once more "abstracted from" some level of reality, although in ways that are much more elaborate and indirect than in the past. Perhaps the phrase "extracted from" might be more accurate for the surgically precise processes of selection, synthesis, and juxtaposition that guide many contemporary abstract artists. At times their efforts can seem so representational as to make the term "abstract" seem inapplicable. And in fact it may well be that the single most important achievement of art between 1970 and 1985 has been to permanently blur the line between abstraction and representation. Still, however much changed, abstraction persists in contemporary art—as a concept, a visual code and a vital, beloved tradition.

This exhibition hopes to demonstrate that today abstraction is being broached on many different fronts in many different guises and is motivated by many different intentions. It is being analyzed and examined, sized up, and pushed out of shape. (You might say that it has lost its diplomatic immunity.) Rather than being an ideal goal, like Mount Everest, it has become a tool, a reference point, and in some instances an historical subject unto itself. It has become an idea to work with and against, to be taken for granted and cross-examined, built upon and undermined, honored and parodied. It is seldom used "straight up," but rather in relation to, in tandem with, or in contradistinction to a host of other ideas. Thus the concept of the hybrid, the mutant and mongrel, is nearly indispensable to an understanding of abstraction's present condition.

Throughout this exhibition, a corrupted formalist consciousness holds sway, an approach founded on the recognition that, to paraphrase Freud, either everything has meaning or nothing does. Nearly every artist represented here traffics in the duplicity of images, materials, forms, or signs, and in the ability of these things to support multiple meanings. It is the pursuit of these meanings that distinguishes much of the work in this exhibition, as it does current abstraction in general.

In a sense, the artists included in *Abstraction in Question* might each be seen to represent a different point on the grid of abstract art. While some of these points can seem mutually exclusive, there are many connections to be drawn between them based on one shared trait or another.

In order to suggest some of the roots of abstraction's current impure state, this exhibition begins with the work of four artists who emerged in the late 1950s and early 1960s, working in the terrain opened up by Johns, Rauschenberg, et al. Their efforts (which continue to develop) establish precedents for many of the issues that concern younger artists today. These artists might be seen to define the four corners of the grid of abstraction that is made partially manifest by this show.

In John Chamberlain's brightly colored crushed metal sculpture (see pls. 6, 7), two qualities are especially relevant: first, a flagrant formal decorativeness; and, second, the use of everyday materials that, for all their rough beauty, avoid any fine art reference. The work of Richard Artschwager offers an early example of the abstract-representational hybrid prominent in recent art. At the same time, despite the distance between Artschwager's restrained irony and Chamberlain's flamboyance, their work displays a shared tendency to fuse the pictorial and the sculptural that has also been quite influential on younger abstract artists.

In Roy Lichtenstein's *Paintings: Abstractions* (pl. 27) of 1984, we see abstraction as recycled style (in this case Abstract Expressionist), appropriated by an artist who has based his career on lifting images from both high and low culture, from both abstract and representational art.

Gerhard Richter's abstract paintings can have the formal brashness of Chamberlain's crushed metal forms and the cool cerebral quality of Artschwager's grisaille hybrid objects. Like Lichtenstein, he exploits both the process and the look of mechanical reproduction, producing deadpan replicas of photographs as well as abstract paintings that can resemble huge enlargements of violently blurred photographs (see pls. 33, 34). Unlike any of these artists, however, Richter never fails to offer the viewer distinctly physical presentations of paint-as-paint, in various

Fig. 2
Robert Ryman
Guild, 1982
Enamelac on fiberglass with aluminum
38 1/2 x 36 in.
Private Collection, New York

states. This is a quality his work shares with Robert Ryman's, although Ryman's investigation of the physical nature of abstract painting extends to the surfaces he paints on and their attachment to the wall, all of which he varies tremendously from work to work (see fig. 2). All the more pity, his art will not be seen in this exhibition; it would add an important "fifth corner" to the grid.

For some of the younger artists in *Abstraction in Question*, the abstract is a kind of autonomous ingredient to be sharply, and often ironically, contrasted—rather than integrated with other elements. It may be quite literally the backdrop against which, or the base upon which, other systems of information or representation are deployed.

For example, several artists in this exhibition take the monochrome painting—perhaps the stereotypical symbol for advanced (or terminal) modernism—as a point of departure. In their work *Star Search* (pl. 44), the artist team of Wallace & Donohue use just such a monochrome canvas—painted an innocuous shade of pale pink—as the support for a vertical row of high-powered track lights, five in all. These turn the tables on the viewer, returning his gaze with an intensity that suggests modern art is indeed "difficult" to look at. The work's title, taken from a television talent show, activates a series of visual-verbal plays. The lights are like stars, but they are also searching for stars. In addition they are directed at the art audience, which has its own insatiable desire for art stars.

In *The Artist Disappears* (pl. 45), Wallace & Donohue also stress the desire for the artist, as opposed to the art work. Here they adorn another monochrome canvas with a large horizontal duct made of wood, a veritable escape tunnel. Its front panel can slide open or closed, which also suggests a magician's magic trick box, albeit one that never succeeds in "reappearing" the artist.

In *Vacancy* (fig. 3; pl. 25), Annette Lemieux plants a small red star, suggestive of a lost soul or a military medal, in the middle of a dark monochrome canvas. With understated poetic effect, she then pairs the canvas with a modern facsimile of an old, empty, oval frame made of glass. In Lemieux's *The Human Comedy* (pl. 24), a generic 1960s-type abstraction is defaced by little ink portraits of Ralph Kramden and Ed Norton of "Honeymooners" fame. Visible only at close range, these faces convert the work's title into a punchline, calling abstraction, and perhaps much more, into question.

Sarah Charlesworth's photographs use the saturated monochromes of abstraction to present highly desirable cultural trophies from both her own and other cultures. A modern chair, an American Indian bowl, and an exotic bronze mask are featured in the works in this exhibition—each isolated in a plane of color that underscores the Western tendency to aestheticize, and therefore to abstract, anything foreign or different (see pls. 8, 9, 10).

Haim Steinbach pursues similar effects in three dimensions. Steinbach starts with jutting cantilevered shelves covered with colored Formica and redolent of Minimalism, on which he displays trophies of a decidedly unexotic nature. For example, two pairs of sneakers and a stack of wood trays from Conrans—the latter forming an ambiguously abstract configuration—are the trophies displayed in *no wires, no power cord* (pl. 37).

Steinbach's combinations have an elliptical precision about them that can often stimulate careful considerations of form and function, color and social value, metaphor and material. In

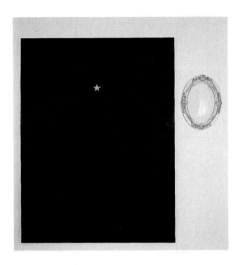

Fig. 3
Annette Lemieux
Vacancy, 1986
Oil on canvas and frame with glass
92 x 72 in.
Collection of Columbe and Leonard Rosenberg,
Courtesy of Josh Baer Gallery, New York

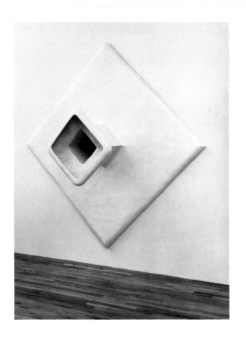

Fig. 4
Robert Gober
The Kaleidoscopic Sink, 1985
Plaster, wood, steel, wire lath and
semi-gloss enamel
100 x 100 x 24 in.
Collection of Edward R. Downe, Jr.,
New York

00:06(2,4L) (pl. 38), a strangely funereal work, the artist contrasts two very different kinds of containers: a pair of gleaming black trash receptacles and four gold and blue lava lamps. The comparisons are several: black versus color, opaque versus transparent, function versus pleasure, empty versus full, stationary versus moving, dead versus alive. In the end, the trash cans come to resemble sentinels for the relatively free, but not so free, spirits of the lava lamps. In this manner Steinbach might be said to extract the abstract (as well as the literary) component from everyday commodities, forcing the viewer, in the experiencing of the work, to retrace the same process of abstraction.

Andres Serrano, also like Sarah Charlesworth, uses the camera to create immaculate fields of saturated color that, in his case, are left bare and arranged into iconic, flag-like configurations. These mimic in photographic terms the rudiments of abstract painting. In addition, these color fields and shapes are informed by an inexplicable physical reality—a hint of surface reflection here and there, for example—that is explained by the artist's titles. *Circle of Blood* (pl. 35) is just that (and its yellow background is urine). The same holds true for the pure white and red rectangles of *Milk, Blood* (pl. 36). In this manner, while in some sense parodying abstraction, Serrano conflates the fundamental forms of art with the fundamental substances of life.

At other times, abstraction seems to provide a work's finishing touches rather than its jumping-off point; it becomes the icing on the cake. This is true of Robert Gober's mutant plumbing fixtures. Descendents of Duchamp's urinals, his abridged sinks are nonetheless covered with a tenderly handmade white surface that conjures up spiritual monochromes from Malevich and Mondrian to Ryman. At the same time, the sinks also seem to parody and to wryly domesticate previous "breakthroughs" in abstraction.

For example, Gober's *Kaleidoscopic Sink* (fig. 4; pl. 18) seems to have spun itself into a configuration reminiscent of a diamond-shaped painting by Kenneth Noland (or John Chamberlain's *Conrad,* for that matter). On the other hand, the decidedly frightening open maw of Gober's *Scary Sink* (pl. 17) evokes various sculptural "corner pieces" by Robert Morris, Richard Serra, and so forth.

Tony Cragg's work from the early 1980s disdains fine art materials and relies largely on discarded objects, fragments, and materials. In *Blue Drawing* (pl. 12) of 1984, for example, he arranges three much-used crates and three suggestively shaped horn cases against a wall, contrasting the general and specific usefulness of these items, while also playing on the convention of the musical instrument-as-female-form in twentieth-century art. Adding a second art allusion, Cragg then covers the entire makeshift arrangement with repeating crisscross blue marks that have all the programmed regularity of a Sol Lewitt wall drawing.

It's clear from the few works discussed so far that, in contemporary art, elements of abstraction are often juxtaposed with phenomena and references—from lava lamps and other domestic objects to T.V. shows—taken from popular culture. The instances of this occurrence within this exhibition alone are countless. Another example is Philip Taaffe's small, not altogether characteristic painting titled *Strangulation with Necktie* (pl. 39), in which the Playboy Bunny symbol is paired with a biomorphic

shape taken from a 1928 relief by Jean Arp that doubles provocatively as both bow tie and strangled circle. Arp intended the first meaning, since his own work was titled *Shirt and Tie*. Taaffe's title adds the second interpretation. In much the same spirit is Rosemarie Trockel's painting made with an industrial knitting machine which, thanks to the "Pro" logo, presents a relatively routine abstract motif as if it were a swatch of athletic clothing (see pl. 43).

In the work of several other artists in this exhibition, purely pictorial aspects of popular culture are completely absorbed into the formal mechanism of abstraction, creating elaborate fusions of the two. In the painting of Elizabeth Murray and Carroll Dunham, for example, Surrealism seems to have entered through the back door, by way of popular culture's cartoon animation—where Surrealism has long exerted a strong influence.

Murray turns abstract painting into a living, breathing dimensional thing, fraught with physiological motion and psychological conflict—although she is rarely specific (see pls. 28, 29). Twisting and writhing, her painted shapes and shaped canvases have an exaggerated plasticity; they seem to want to be free of each other and even of the wall. At the same time, Murray's focus on the physical facts of canvas and stretcher (unexpected holes, torqued surfaces, and flapping corners, for example), however expressionistic it may seem, has its precedent in Ryman's more classical example.

In a manner similar to Murray, Dunham mixes the rudiments of abstraction—line, shape, color, and space—with the rudiments of psychology and sets them in motion. Suggestive of a range of body parts and functions, his brightly colored shapes plop, fizz, and ooze, often at top speed. The result, as *Transit* (pl. 14) and especially *Fifth Pine* (pl. 13) demonstrate, is a kind of stream-of-consciousness abstraction in which the good, the bad, the beautiful, and the ugly attract and repel each other. Up close it is apparent that Dunham's motifs are also to some extent generated by the swirls, knots, and grain of the wood veneers they are painted on, creating a hyperactive version of the formalist self-references of earlier abstraction.

Since the late 1970s, Judy Pfaff has found different ways to bring into real space the complex orchestrations of form and color that have always been possible in abstract painting. Sometimes the scale of her work has been environmental, as in *Rorschach* (fig. 5), the elaborate installation piece she constructed at the Ringling Museum in 1981. Lately, however, Pfaff has concentrated on smaller, but monumental-scaled wall pieces made of brightly colored metal and plastic elements that come in all shapes, sizes, and linear configurations (see pls. 31, 32). The result is a mongrel abstraction of explosive formal energy and unusual extra-aesthetic familiarity. The individual parts of Pfaff's structures speak more of store signs, billboards, and the hardware store than of the art gallery; as totalities, they propose the artist as an heir to both Stuart Davis and John Chamberlain.

There are several other artists in this exhibition, who, like Judy Pfaff, broach abstraction using materials and processes that are decidedly unabstract, and that come fully equipped with their own meanings and implications. This is the case, as we have seen, with the work of Andres Serrano and Tony Cragg, among others.

A second work in this exhibition by Cragg (in addition to his *Blue Drawing*) makes particularly direct use of the abstractness of non-abstract materials, in this case society's refuse. *Newton's Tone - New Stones* (pl. 11), from 1982, consists entirely of discarded plastic objects and fragments arranged on the floor in an orderly rectangle (not unlike a Carl Andre sculpture) according to their colors, which add up to a fairly complete spectrum. Cragg's ordering process formalizes and purifies his materials, so that we see their abstractness. At the same time, his practice of recycling what is clearly not biodegradable also comments on society's ecological arrogance and its incessant cycles of waste and obsolescence.

In other instances, it is eccentric processes as much as unusual materials that bring a more worldly focus to abstraction. Rosemarie Trockel's use of the industrial knitting machine, mentioned earlier, and Christopher Wool's use of rolled-on stencil patterns (see pls. 48, 49) give their art an anonymous, mass-produced quality that nonetheless alludes to handicrafts and domesticity. In this matter different references to labor and to painting as a commodity are layered together.

Wool's graceful black stencil patterns are commonly used to decorate walls, where they create an inexpensive alternative to wallpaper. Wool applies this relatively old-fashioned technique to a surface that probably didn't exist when the roll-on stencil was invented: a gleaming white panel of aluminum. Thus, he combines innocent decoration with sophisticated utility to offer his own ironic yet homespun solution to a classic "problem" of 1960s abstraction: the flatness of the picture plane.

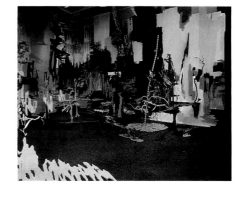

Fig. 5
Judy Pfaff
Rorschach, 1981
Detail of installation at
The John and Mable Ringling Museum of Art,
Sarasota, Florida, October 29-November 29, 1981

The sweater-like surface of Trockel's *Untitled* (hammer and sickle flag) (pl. 42) converts two relatively benign conventions—the modernist grid and the knitting design—into a vehicle of Soviet propaganda. It may also be pertinent, to a motif that evokes the world's premier Communist country, that a knitting machine is a "labor-saving" device.

Diana Formisano's heavily-framed photographs suggest a level of technology more advanced than the roll-on stencil or the knitting machine. Her grainy, abstract images seem to be computer-generated, although they actually result from repeatedly photographing the same image. They are insubstantial, leaving us with the sensation of looking at nothing but shifting dots of light and non-light.

Still, in a way that seems almost conservative, Formisano's work evokes timeless forms and symbols. In *Red Cross* (pl. 16), four black-and-white images encroach on a field of red to create the motif of the work's title. In *Aggregate* (pl. 15), Formisano shifts from the iconic to the perceptual, giving us a series of separate views that seem to demonstrate the very process of "abstracting from" a visible structure, but that also retain an aspect of religiosity in the resemblance to stained glass.

For the final group of artists in this exhibition, abstraction is given greater self-awareness and perhaps greater relevance by being cross-referenced with, or put to the service of, various forms of history—be it social history, art history, natural history, or whatever.

Peter Halley, for example, combines elements of rigorous reductivist abstraction with visualizations of power systems and social structures (see pls. 19, 20). In a sense, Halley is in the process of formulating an international sign system that grimly diagrams how society works—or doesn't. His colors are either high-voltage fluorescents or burnt-out blacks; there are no in-betweens. His narrow formal vocabulary of large or small squares and single or parallel lines denotes (as his titles reveal) factories, electrical cells, or prison cells—forms that all figure prominently in the regulation and circulation of power, whether in terms of goods, services, or human behavior. Thus Halley, while adhering to modernist abstraction with unusual devotion, converts its codes into unsettling landscapes of post-industrial life.

Ronald Jones' work, which has strong affinities to Conceptual Art, forces the viewer to confront abstraction's role in the actual course of human events. Each of his works extracts the geometric from a specific real-life drama, showing geometry to be either emblem, symptom, or collaborator.

One piece in this exhibition consists of seven geometric painted wood wall reliefs, each sixteen inches in diameter (see pl. 23). As its title cryptically explains, the work contrasts the difference between the attitudes of North Vietnam and the United States on the eve of the 1969 peace talks, by presenting the designs for the shape of the peace conference table submitted by each side. The United States submitted six designs, the North Vietnamese submitted one, which was also the simplest—a contrast that may say something about the outcome of the war.

In another series of wood wall reliefs by Jones, three examples of which are included here, an irregular geometric shape is held to the wall by four wood dowels (see pls. 21, 22). The works' common title delineates a grim tale. The shape is derived from the floor plan of Eric Mendelsohn's innovative International Style Columbushaus, completed in Berlin in 1932 and used by the Nazis as an urban concentration camp between 1933 and 1936. The reliefs are pinned to the walls at different angles, as if under stress; on the back of each is a woodcut by an anonymous inmate of Columbushaus, depicting the torture carried out there.

Jones' titles are indispensable; without them, you don't know what you are looking at. This is didactic, but it is also part of Jones' message: you can't fully understand something until all of its applications have been laid bare. Again and again, his art charts abstraction's loss of innocence and its complicity in history.

The history that Philip Taaffe delves into is more local; it is the history of abstraction itself. He retrieves styles and even specific paintings from the past, updating them with his own alterations and additions. Taaffe is perhaps best known for adding rope-like twists to the vertical "zips" in his renditions of certain Barnett Newman paintings. But, despite their frequent wit, Taaffe's updates are more gestures of homage than parody; and his goal seems to be to revive the spiritual content of abstract art.

This is perhaps more evident when Taaffe's sources are more obscure and his copies less exact. *Pharos* (pl. 40), for example, has the look of Op Art, and is reminiscent of Vasarely, without being based on any existing painting. It is not by chance that Taaffe's

Fig. 6
Philip Taaffe
Rebound, 1987
Enamel, silkscreen and acrylic on canvas
65 x 65 in.
Private Collection, New York

black-and-white pattern of repeating triangles and diamonds culminates in two crosses at the painting's central spine, or that, using a combination of collage and pale tints of color, the artist creates a faint aurole of light around these crosses.

In *Polygon* (pl. 41) of 1987, Taaffe multiplies several biomorphic shapes (plus a few circles) from a work by the little-known American abstractionist Charles Shaw, creating a field of wavering, almost ghost-like clouds and even the light of an eery nocturne. And in *Rebound* (fig. 6) a black-and-white painting of the same name by Ellsworth Kelly becomes the background for a series of delicately touching curved shapes based on a motif by Arp. The added shapes echo the rounded edges in the Kelly work, but they also add an unexpected animation, suggesting baby serpents basking in the sun or squirming microbes seen through a microscope.

The histories that Terry Winters brings to bear on abstraction are natural and scientific. His paintings are at once lushly physical and diagrammatic, reflections of human knowledge (in several disciplines) and of raw, natural fact (see pls. 46, 47). Winters' evocative abstract and semi-abstract forms are based on an array of relatively unknown natural structures (variously plant, mineral, and animal) and are suspended in surfaces that range from open and spatially ambiguous, to closed and densely impacted (as the two paintings in this exhibition reveal). In a sense, his work extracts abstraction from the course of natural events, suggesting that it exists independently of human ingenuity or desire. Yet this found formal vocabulary is psychologically and physically suggestive, and the means by which it is conveyed—painting—is extravagantly articulated. In the range of drawing and painting techniques deployed throughout his work, Winters demonstrates the physical possibilities—or inherent "nature"—of painting, as well as its equally artificial character as a form of discipline and knowledge. In this manner, his mysterious images delineate a balance between matter and information, and between the natural world and human understanding of it.

The history in Ross Bleckner's abstraction is the personal history of memory and the concomitant desire to live beyond history—to be immortal, or at least remembered. Hovering between intense sentiment and sentimentality, between drama and melodrama, Bleckner's paintings combine various abstract staples—particularly the stripe and the monochromatic field—with emblems and motifs redolent of earlier times and earlier, pre-abstract art.

In one painting in this exhibition (see pl. 5), a shield-like keyhole transforms a field of vertical stripes into the gate of its title, but the keyhole is itself also the gate, far away and impossible to reach. In the other, *Architecture of the Sky III* (pl. 4), dabs of white paint double as muted stars; and their curved rows push the painting's grey ground inward until the illusion of an enormous vault—part observatory, part dome of heaven—is created.

In a sense, Bleckner's work harks back, almost nostalgically, to a time when religion guaranteed art both subject matter and legibility, as well as an important place in society. Although that degree of symbiosis is gone for good, the artists in this exhibition, and many others, are working to achieve a new measure of meaning and place for abstraction as its great first century draws to a close. ■

READYMADE ABSTRACTION/ABSTRACTION'S REALITIES

By Joan Simon

ABSTRACTION is a term that is most often defined by what it is not. In the language of modern art, abstraction has meant non-representation—a work of art having little or no descriptive relationship to the recognizable world. The absence of a figure or an object has been its basic condition; hence the synonymous terms "non-figurative" and "non-objective."

What we have learned to expect from an abstraction, plainly stated, is a display of lines, colors, and shapes. The way a piece is conceived and constructed determines its identity as an aesthetic object in the world—though something distinctly separate from it—and constitutes the full scope of its meaning. (Because such a work refers only to itself, to the elements that determine its form, the terms "self-referential" and "formalist" have also come into play as somewhat circular, if positively stated, indeed tautological routes to understanding its nature.) And though since the early years of this century abstract works of art have often been generated by an artist's desire to express spiritual, metaphorical, allegorical, personally or politically symbolic ideas as well as structural concerns, such statements made in a generalized, detached visual language—rather than through specific factual details or explicit references to a given time or place—have been necessarily correlatives to, rather than connections with, the world at large.

In this century we have also come to expect artists to confound our expectations—to show us what we do not yet know, or to confront and/or contradict accepted notions. At the end of the 1980s, we see this happening full force. A number of artists, usually gathered together under the rubric Neo Geo, have gained wide attention by deliberately taking abstraction from an ethereal plane, so to speak, and bringing it squarely back to earth. However, the intention to rethink and to remake abstraction, to have it directly engage the world while also recognizing that any art work is fundamentally a thing apart, has been an operative force in critical thinking and vanguard art-making for at least the past twenty years. Pop gave abstraction a vernacular image. Conceptual Art unearthed its voice. Precedents of course go back to Picasso's legendary collages of the 'teens, which conjoined the selected and the invented, and to Duchamp's Readymades, for which he abstracted—that is, seized—the most ordinary of recognizable worldly goods into the realm of art. What is at issue in recent years is deliberately neither newness nor originality; rather, with traditional forms widely in evidence yet called into question, we have witnessed what might be called "born again" abstraction. Fundamental issues, such as value and meaning, are the focus even as formal assets—recognizable, readymade, abstract styles—are the vehicles.

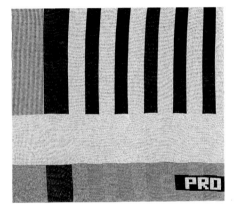

Fig. 7
Rosemarie Trockel
Untitled, 1986
Knitted wool, stretched
57 x 65 in.
Courtesy of Barbara Gladstone Gallery, New York

If the "modern" abstract art object required of the viewer exclusive attention to the tightly circumscribed arena of a work's material presence, the "post-modern" abstraction provokes the viewer to assess the equivalent and often equivocal relationship between a work of art's interior structure and a host of issues that can extend far beyond its borders and not incidentally or accidentally be represented therein. While there have always been impure abstractions in the modern canon—works that refer to the perceptible world despite the best efforts of their maker or that, through a process of generalization, provide what might be called "echoes" of the terrestrial (the distance between the observed and the invented being the essence of its ambiguous position)—the impurity of post-modern abstraction is self-conscious and overt. Its critical and formal stance requires that it do two things at the same time: refer to itself and to something else.

To this end many contemporary artists use the very historical lode of what we expect abstraction to be, what it has previously looked like (including nearly a century's worth of stylistic variations) to create art works that are not only in this world but of it—abstractions that are worldly in reference and appearance. We see abstract works dealing not with mythical hopes but with mundane, often domestic, at times dire, realities. If constructed of the now classic look of organic curves and geometric lines, these reductive, generalized forms are likely to be used to trigger memories of previous eras and artists or to allude to a wide variety of socio-political subjects rather than to stand only for themselves. Traditional materials such as oil on canvas might be used, but so might they be conflated with finds from the junkyard, the hardware store, the industrial mill, and the shopping mall.

Moreover, in this blatant mix of the pure and the impure, high culture and low, low tech and high kitsch, there are indeed representations, ranging from representations of abstraction (logos, signs, and readymade images or objects that are structurally abstract) to the very figures and objects that abstraction was to have minimized if not essentially erased. The artists whose works are included in the exhibition *Abstraction in Question* press at the limits of abstraction in very different ways. (Many of them, indeed, work abstractly at times; representationally at others.) Essentially they question the ability (or inability) of style to voice concerns beyond the parameters of the visual. By treating abstraction as a multi-faceted historical fact—as source, process, image, and tool, as a symbolic as well as a recognizably tangible entity in its own right—they present abstraction as a readymade; but, more importantly, they put it to work to elicit a multitude of contemporary realities.

Rosemarie Trockel knits her "color-fields" on industrial knitting machines, incorporating into the very fabric of her works recognizable symbols as different as the logo of the wool industry (see fig. 7), hammers and sickles (see pl. 42), and the Playboy Bunny. As she has said,

> The patterns I use are, in principle, the ones I come upon in knitting books.... If I knit in a garment or sweater the hammer and sickle, for instance, there is a depreciation of the ideology bound up in identifying the logos for product propaganda and ideological propaganda. We must understand fashion not only as adornment of the body, but as acting for the body of society.... In my work the wave-designs of Op-art (Bridget Riley certainly has had a great influence on Op-art fashion) do not only have this art-historical connection. The serial patterns, just as the social conditions in which they originated, are of interest here, rather than the formalism of the right angle.[1]

In Trockel's work, the personal and the social meet at the very point where structure is formed. "Intertwined" in her textiles are utility and ideology, domesticity and industrial production. In a bold reclamation of knitting (traditional "women's work"), Trockel is not only claiming recognizable yet abstract imagery but also effectively and economically forging the aesthetic and the pragmatic. The body politic in Trockel's work is both the personal and the global.

Robert Gober and Gerhard Richter have also based their works on industrial standards, variously invoking stylistic references as part of a process that, like Trockel's, locates within their choices a layering of memory that condenses past utility, present sensibility, and a precarious but pragmatic readability. And though Gober and Richter use abstract images that are found rather than invented—and that are chosen for the meaning that is to be found in the duplicitous unity of functional resonance and usable

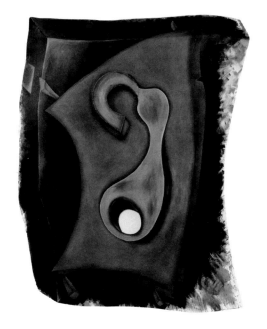

Fig. 8
Elizabeth Murray
Slip Away, 1986
Oil on canvas
129 1/2 x 101 1/2 x 9 in.
Private Collection, New York

style—they both, almost perversely, present their images in works of art so meticulously handcrafted as to appear, quite contradictorily, as if they were mechanically made. Robert Gober's faux-porcelain distended sinks are not quite in sync with his generic sources (see pls. 17, 18). They have an anthropomorphic air as well as a Minimalist preference for pristine surface and industrial palette. Poised in the realm of art, yet deliberately designed to resemble plumbing fixtures, his carefully handmade white, wall-hung reliefs are, as he has said, "more or less humble emblems, permeated by use, waiting for someone to complete them."[2]

In 1966 Gerhard Richter set his attention to commercial color charts, duplicating the format of these objects in paintings whose scale and chromatic seriality reverberate a heightened, oversized functionalism as they simultaneously flag attention to the Minimalist's grid, the Pop artist's reclamation of the most ordinary images and glorification of the manufactured standard, and the Photo-Realist's presentations of a precisionist, mechanically projected reality. With an acute sense of the inherent qualities of a particular found object—Richter's source in this case embodies an intrinsic unity of abstraction and representation, image and fact—and at the same time with an almost romantic attitude toward the painting of unique objects, Richter's approach might very well be seen as summary of this exhibition's paradoxically re-engaged abstractions. As he has said "what I'm attempting in each picture is nothing more than this: to bring together, in a living and viable way, the most different and the most contradictory elements in the greatest possible freedom. Not paradise."[3]

"Not paradise" are John Chamberlain's expressionist sculptures —assemblages of rusted and crumpled car parts (see pls. 6, 7). "Not paradise" are the epidemic losses of life symbolized in Ross Bleckner's reworkings of Op Art—painterly memorials to those who have died of AIDS (see pls. 4, 5). "Not paradise" are the lamps, packaged goods, running shoes, garbage cans, and other curiosities that Haim Steinbach sets out on hard-edged, geometric Formica display shelves (see pls. 37, 38). "Not paradise" are the homely domestic trappings and almost self-portraits of inner turmoil, the extreme pulls between art and life, that often bring Elizabeth Murray's painted canvases to the literal breaking point. Murray's swelling Surrealist biomorphs are equally recognizable as body parts or crashing coffee cups, for example; her Constructivist fragments are separate yet indivisible from their other identities as wildly skewed tables or chairs (see fig. 8; pls. 28, 29).

What is important to consider in these very different pieces by artists of different generations, intentions, and sensibilities, is how they bring abstraction to bear on the making of "paintings of modern life." Facts are presented— admittedly obliquely, at times—rather than rhetorically implied. Abstraction is indeed given a voice, but it is profane rather than sacred. Richter has explained that his Color Charts

... had rather more to do with Pop Art. They were painted color pattern cards, and the beautiful effect of these color patterns was that they were so opposed to the efforts of the Neo-Constructivists, such as Albers, etc.... It was an attack on the false and pious way in which abstraction-ism was celebrated, with a dishonest reverence—treating these squares as something to be revered, like church art.[4]

Or, as Philip Taaffe has described the task in relation to his work, "The painting should say that there's another possible world, by saying, 'Look at the world inside this painting, look at the world outside the painting, and figure out how the two can come together.'"[5]

These propositions are evidenced in all of the works included in the exhibition *Abstraction in Question*. The use of abstraction was a necessary but insufficient criterion for inclusion. Each of the artists uses abstraction as a way of literalizing rather than generalizing about aspects of the here and now. In very different ways they question the validity of abstraction as a purified, universal, spiritual language, offering it not as a lingua franca superseding everyday realities, but as conceptually grounded in those very realities and materially embodied in their ways of making art. Compared to the modernist approach to abstraction prescribing an orthodoxy of purification by denial—Alfred Barr once wrote that the abstract artist "prefers impoverishment to adulteration"[6]—the artists included in this exhibition take almost exactly the opposite route. Their work is inclusive rather than exclusive, open-ended rather than summary, expressive of a multitude of questions rather than proposing absolute answers. Meaning—if not the modernist's pantheistic god—is to be found

Fig. 9

Richard Artschwager

Envelopes, 1966

Acrylic on Celotex

21 x 26 in.

Private Collection, New York

in specific, recognizable details.

Since the early 1960s, Richard Artschwager has made pictorial objects and objectified pictures—using "non-art" materials such as Formica, often in an imitation wood-grain finish, or Celotex, an industrial paint that gives a unified but toothy surface to his canvases (see fig. 9; pls. 1, 2, 3). As early as 1960, Artschwager found his signature material:

> ... Formica, the great ugly material, the horror of the age, which I came to like suddenly because I was sick of looking at all this beautiful wood. . . . So I got hold of a scrap of Formica—something called bleached walnut. It worked differently because it looked as if wood had passed through it, as if the thing only half existed. There was no color at all, and it was very hard and shiny, so that it was a picture of a piece of wood. If you take that and make something out of it, then you have an object. But it's a picture of something at the same time it's an object.[7]

As Richard Armstrong noted about one of Artschwager's earliest pieces using his "horror of the age" material, a shelf of wood backed with a piece of "walnut" Formica, "Artschwager successfully integrated fact (wood) and image (Formica)."[8]

Choosing his found images equally for their abstract and representational qualities—blurred newspaper photos, drapery weaves, shelves, and other architectural elements as well as furniture—Artschwager's works are as socially oriented as they

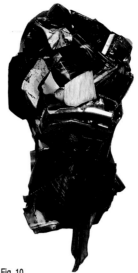

Fig. 10
John Chamberlain
Added Pleasure, 1975-1982
Painted and chromium plated steel
111 x 53 x 36 in.
The John and Mable Ringling Museum of Art,
Sarasota, Florida

are personally eccentric. Non-functional tables, chairs, doors, windows, handles, and isolated grammatical structures, such as volumetric exclamation points suspended in the midst of a gallery, are concrete abstracted figures isolated only to be contextualized as tangible realities. Artschwager's furniture pieces, in particular, are formally related to Minimalist cubes; yet they have an uncanny social presence. It is the matter-of-fact duality of both content and style in Artschwager's work that gives his pieces a confident rather than confrontational presence. While they do not have a deliberate social agenda, a programmatic purpose, they have a posture that partakes of both the functional and the formal.

Peter Halley's and Terry Winters' paintings also integrate fact and image. Both use an abstract language to denote the not easily visible structural imperatives of our daily lives. Peter Halley's Day-Glo geometries (see pl. 19), as bold and seductive as neon signs signaling the psychedelia of the 1960s and as methodically composed as Joseph Albers' squares within squares, are meant to be representations of prison cells and other less apparent but no less oppressive structures that literally shape our lives: electrical conduits, computer chips, the right-angled schema of architectural standards.

> One of the initial motivations in my work is that when I first came to New York, I was so fascinated by facades and decoration. If you went into an office building everything was covered with marble, or wood paneling, or what have you. And I was fascinated by the idea that the conduits, the supportive structure, was always hidden. I thought to some extent this was a characteristic of contemporary society, or of capitalism in general. I aspired to actually ferret out and bring forward some of those structural conditions that existed behind the facades, if you will.[9]

Terry Winters' images are known to us through technology, but the images themselves are of age-old organic structures (see pls. 46, 47). Like Halley's, Winters' subject matter is a sort usually hidden from view; but unlike Halley's subject matter, Winters' is only indirectly about technology. Winters' painterly canvases contain abstract images whose sources are things that are "relatively new," as Stephen Ellis has pointed out,

> ... in the sense of our awareness and structural understanding of them: vascular systems, microscopic plant and animal cells, mineral crystals and the biological building blocks of nature. They are things, pace Johns, the mind does not already know. Yet known only indirectly through scientific aids, they have become an essential part of our contemporary understanding of who and what we are.[10]

Fact and image are as one in John Chamberlain's irreducible abstract mark (see fig. 10; pls. 6, 7). Though Chamberlain constructs his pieces intuitively —he assembles his found objects to create what he calls the right "fit"—it is impossible to look at his works without recognizing their elements' former use, and seeing that within these glittery and rather glamorous though muted assemblages are both a self-referential "scape" and a fragment of a larger industrial blight. Arrested, distressed, frozen in a particular moment, each of Chamberlain's car parts refers back to a utilitarian past, certainly not to a utopian present or future. Art and life; fact and image; and abstraction, representation, and reality are located within his readymade yet multi-expressive mark. Indeed, he has inverted the Abstract Expressionist's "arena in which to act" to the specific elements already acted upon.

By contrast, Judy Pfaff's freewheeling and freestanding concretizations of the Abstract Expressionist's gesture are ap-

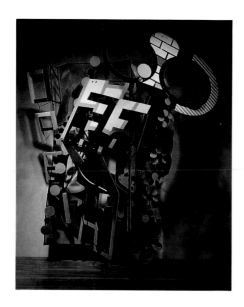

Fig. 11
Judy Pfaff
Great Glasses, 1988
Mixed media
108 x 96 x 60 in.
Courtesy of Holly Solomon Gallery, New York

propriations in both a conceptual and pragmatic sense (see fig. 11; pls. 30, 31, 32). Her bold strokes made of industrial plastics, traffic signs, and at times lawn furniture, have a boisterous animation that is in many ways the opposite in tone and posture of Chamberlain's. While his are factual, sober mementos, irreducible marks implicitly unifying style and substance—actual appropriations—hers are boisterous celebrations of the gestural mark set free. Pfaff allows her "strokes"—larger than life-size and constructed of the most familiar materials of the everyday, often suburban world—to take their place as characters, actors, figures along with their audience in room-sized installations.

The utility of the Abstract Expressionist mark is brought to almost iconic status at the same time it is offered as a commonplace in Roy Lichtenstein's paintings (see pl. 27). Though Lichtenstein has reworked and incorporated into his paintings a host of abstract styles and images, from Moderne and Matisse to Surrealism and the stylistics of photo-offset printing, his use of the Abstract Expressionist "brushstroke" in many ways over many years is particularly complex. Whether it serves as a comic figure, as familiar and bold as one of his cartoon character appropriations, or, more recently, standing in our space as the armature of a chair (see pl. 26), Lichtenstein emphatically makes us realize that the precise isolated stylistic fragment—the essential mark of abstraction—is neither image-neutral nor content-free.

Curiously, the appropriation of an Abstract Expressionist image, and its implicit figurative presence, has gained little attention compared to the predominant recycling, geometric, hard-edged abstract styles. Perhaps to call the gestural and the personal into question is even more iconoclastic than to mechanically record a precisionist abstracted "reality." Gerhard Richter's reproductions of Abstract Expressionist fields seem to convey their inviolability as his paintings cooly deconstruct, desanctify, and reconstruct the language (see pl. 33 and cover).

To many observers of the contemporary art world, abstraction appears to have been reborn somewhere around 1985. When a hallowed iconography that had never really been lost was found anew and energetically presented in profane garb, the attendant trappings and controversial response, perhaps not surprisingly, had much in common with other contemporaneous manifestations of born-again evangelism: believers with "the word" made themselves known, prophets were newly (if often reluctantly) claimed, and a host of suspicious debunkers saw in all of this not a hope for a renewed tradition—but simply hype.

The work that prompted the controversy was revivalist in spirit as well as in form. Variously labeled Smart, Simulationist or Appropriation Art, Neo-Conceptualism, and Neo Geo—the latter seems to have stuck—it merged an entire century's accumulated assumptions about abstraction with Pop Art's glorification of the vernacular and Conceptualism's theoretical provocations. It absorbed aesthetic and linguistic theory, store-bought goods and a variety of other readymades, both stylistic and serviceable. It had a distinct, polished physical presence and often a didactic social agenda. Though the works were individually different in ambition and formal presentation, collectively they seemed to displace, subvert, and subsume the accomplishments of preceding generations of artists with a liturgy that was as apocalyptic as it was commonplace.

For some practitioners, the programmatic use of abstraction, a rather matter-of-fact display of what had been revered sometimes as a neutral and often as a spiritual or sacred visual language transcending everyday realities, deliberately signaled the death of modernism—of the progressively reductive universalizing impulse in art making, of art for art's sake. It was argued that abstraction had been so emptied of meaning that what remained was merely a hollow shell—a recognizable surface, and a saleable image like any other—devoid of substance, as useful or useless as any other artifact. Indeed, these stylistic fragments were studied, reshelved, and pragmatically reused in the new abstraction in a variety of ways: as curiosities, commodities, reliquaries, touchstones, symbols of former utility and value. Curiously, for those who had previously heard rumors of modernism's as well as the art object's death, if this truly was the end, the enterprise was going out with a showy bang rather than with the whimper of Conceptualism's dematerialization of the object into pure idea.

If faith in an isolated, even icy, visual language was in question, it was also widely in evidence. Philip Taaffe's restructuring of Bridget Riley, Barnett Newman, and others, on the surface at least, accorded formal properties the flattery of imitation while conceptually calling our understanding of such idioms into question (see pls. 39, 40, 41). With style

wrenched from previous contexts, divorced from the exigencies, aspirations, and ambitions—as well as from the cultural, socio-economic and political climate of the times in which it was made—the question "what meaning and value does abstraction now have?" was laid bare.

The characteristics of consumption in all the complex and contradictory implications of the word—absorbing, engrossing, devouring, dissipating, and most obviously shopping—were part of the work's critical program as well as its aesthetic posture, and no less a part of its controversial reception. These reclamations of abstraction were initially met with simple and summary reactions: the aforementioned hope or hype. But in looking at the diverse approaches of the artists, this new abstraction constituted neither a cyclical stylistic shift (a reaction to the bombastic, figurative expressionist painting that took center stage from 1980 to 1985) nor a cynical market turn (a vacuum to be filled with a new, different-looking product). The art works themselves, however, did resemble commercial products; they were professional-looking, carefully constructed packages that were cooled down rather than heated up, conceptually strategic rather than intuitive, socially oriented rather than personally revelatory.

While reactionary toward other art and toward vanguard disengagement from the art market, these conditions alone do not begin to explain the work's aesthetic premises nor to get at the raw nerve it seemed to have touched. If all this work did was to call attention to its stylistic antecedents it might, in sociological terms, be considered investigative reporting or in art historical terms be viewed as a savvy, stylish kind of homage to the methodology of assembling readymades, chief among them recognizable abstract styles. Neither of these possibilities can be discounted. And though it is far too early to tell whether a larger contribution will have been made by the new abstraction, it is indeed apparent that the work has successfully raised, if not fully answered, certain larger questions.

For what is essentially at stake in this particular breed of reborn abstraction are basic questions—"What is the meaning of value?" and its corollary, "What is the value of meaning?" Most important, can a work of art and especially an abstract work of art, rather than a written or spoken text, speak to or bespeak these larger issues?

To attempt to engage abstraction—to have it not only be in this world but of it, in content as well as in "contents"—is a very large ambition, and one that, though extremely welcome, is more easily stated than achieved. (The textual exegeses of Neo Geo, by both critics and the artists themselves, have often been more convincing in conveying content than are the art works themselves.) For, necessarily, such an objective places an extremely heavy burden on the art object—on the formal qualities of the chosen elements, whether found or invented, mechanical or handmade.

Perhaps the most successful practitioner making such re-contextualized abstractions out of readymade abstract styles is Ross Bleckner. His *16,301+ as of January 1987* (fig. 12) conveys its mournful, documentary presence with the most minimal of shadowy abstract means. In its moody surface and with its numbers—the count of those who had died of AIDS at the time of the making of the painting—it details the facts as it equally evokes, in the chiaroscuro glimmerings of its surface, an elegiac tone. Our visceral sense of loss and mourning, of possibility and inevitability, is elicited by both figure and ground—one and the same thing. For this viewer at least, the painting has left an indelible mark: his numbers are as deeply etched in memory as the branded numbers on the arms of Holocaust survivors. Bleckner has provided a baseline for consciousness through fact and image.

In contrast, Haim Steinbach's store-bought goods, while evidently tangible reminders of the larger culture, remain almost mute in telling a story other than the formality of their juxtapositions. His choices are unfailingly provocative (he has a superb eye for graphic design and for the stylish cultural artifact). Yet, while they tantalize, his choices almost always cancel each other. Steinbach's placement of, say, a pair of footballs next to a woven wicker basket on one of his streamlined wall-hung shelves hints at the compare-and-contrast method of looking at slides in an art history class, while also provoking thoughts about art and commerce, work and leisure, production and consumption. What remains most curious about Steinbach's pairings is that the comparisons do not lead to judgment or conclusion, but rather to equivalence; and equivalence to neutrality rather than criticality. In his works 1 + 1 adds up not to 2 but, exactly and only, to 1 + 1. His title for the football and wicker work *dramatic yet neutral* (fig. 13) precisely sums up its affect.

Steinbach's reshelved products, despite their representational familiarity, function in a conceptual arena that is almost too abstract.

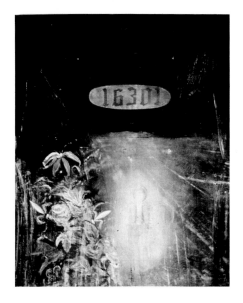

Fig. 12
Ross Bleckner
16,301+ as of January, 1987, 1987
Oil on linen
48 x 40 in.
Private Collection

There's something I know which most people know about the objects I use in my work because of their commonality. They are bought or taken, placed, matched and compared. They are moveable, arranged in a particular way, and when they get packed they are taken apart again, and they're as permanent as objects are when you buy them out of a store. So the question of permanence is just relative to everything else in this exchange that allows anything to be permanent or not. I am more interested in exchange, and what happens in the exchange, and the different stations of that exchange. By this I mean, the stages where things stop and are in a certain order. Hopefully my work allows the spectator to have a bit of consciousness of some aspect of order within this society which makes for what is often taken for "the natural order of things." Possibly, this approach of participating in the fluency and the variations of this exchange, and the establishing of stations, or points in time, where things stand, stops the spectator as an "individual" and allows for a moment of recognition.[11]

Discerning the criticality of a Steinbach sculpture or a Halley painting is a task that is extremely difficult without their words as precise guides. Though Steinbach's choices of objects—pieces of driftwood, lava lamps, shoes with orthopedic braces attached—add an exoticism and thereby an aura of subject matter, his assemblages are essentially formal arrangements (so formal in fact, that his "still lifes" are reminiscent less of memento mori than the cool elegance and rule-bound design of Ikebana). The intentional socio-political content of a Halley painting, indeed the representational aspect of his lines and grids, is virtually imperceptible. This is not to say that his are not strong, even daring paintings, with a presence and a particularity all their own. Rather it is to state that these acutely formal works succeed with a singular rather than doubled image—they have a look that comments on art, but lack a voice that comments on life.

Neo Geo has focused attention on artists' hopes to contextualize and, in a sense, to socialize abstraction. It has also triggered new thinking about other abstract works of art whose makers have put abstraction to work, either implicitly or intentionally. A desire for meaning, though, is but part of the story; the clarity with which meaning makes itself evident is its counterpart.

For abstraction to fully accomplish a double mission of taking its place as an isolated aesthetic object in the world and also of engaging the world by voicing the complex and contradictory times we live in, requires of its maker the acuity to load the object with enough recognizable visual information for both positions to be readable. The audience, in turn, must allow for the possibility that abstraction can hold a multiplicity of realities.

What is required is not the modernist's willing suspension of disbelief—a kind of universalist blind faith—but a telling retention of what belief is and what, in art, by virtue of its visual and tangible presence and the clarity of its particulars, is indeed believable. F. Scott Fitzgerald once said something to the effect that genius is the ability to hold two contradictory thoughts in mind at the same time. In looking at abstraction that indeed essentially contradicts its own historical premises, one is reminded that the two thoughts must be self-evidently available for such beholding to take place. ■

Fig. 13

Haim Steinbach

dramatic yet neutral, 1984

Mixed media construction

39 x 47 x 17 1/4 in.

Private Collection

1. Jutta Koether, "Rosemarie Trockel," *Flash Art* 134 (May 1987): 41.

2. Dan Cameron, *NY Art Now: The Saatchi Collection* (Giancarlo Politi Editore, n.d.), 54.

3. Benjamin H. D. Buchloh, "Interview with Gerhard Richter," trans. Stephen P. Duffy, in *Gerhard Richter: Paintings*, ed. Terry A. Neff (New York: Thames and Hudson, 1988), 29.

4. Ibid., 19.

5. Dan Cameron, *NY Art Now*, 23.

6. Alfred Barr, "Cubism and Abstract Art: An Introduction," in *Defining Modern Art: Selected Writings of Alfred H. Barr, Jr.*, ed. Irving Sandler and Amy Newman (New York: Harry N. Abrams, Inc., 1986), 86. "Cubism and Abstract Art" was a 1936 exhibition that Alfred Barr organized at the Museum of Modern Art. It was to be the first in a projected series of shows intended to illustrate some of the principal movements in modern art. His discussion of the "confusing and even paradoxical" definition of the term "abstract" was valuable in thinking about the works in *Abstraction in Question*. Though Barr was in fact tracing the lineage of the two main traditions of "Pure" abstract art, the geometric and organic—or as he put it, the "shape of the square" versus the "silhouette of the amoeba"— he necessarily treated the related problems of "impurity." His entries, which sound remarkably like an index to the present redefinitions and reuse of abstraction include: "Abstract," "Near-abstractions and Pure-abstractions," "Dialectic of Abstract Art," "Near-abstractions and their titles," "Abstract Art and Subject Matter," "Abstract Art and Politics."

7. Richard Armstrong, "Art Without Boundaries," in *Artschwager, Richard* (New York and London: Whitney Museum of American Art, in association with W. W. Norton & Co., 1988), 17.

8. Ibid.

9. Dan Cameron, *NY Art Now*, 18.

10. Stephen Ellis, "Metaphorical Morphologies," *Art in America* 76, No. 9 (September 1988): 152.

11. Dan Cameron, *NY Art Now*, 41.

PARADOXICAL IMAGES

By Bruce W. Ferguson

An oxymoron often consists of two words forming a figure of speech that provides an essentially contradictory but not necessarily absurd meaning. Or it might be a figure of speech that initially appears foolish but that is actually incisive. It is just like its origins—*oxys*, meaning sharp, and *moros*, meaning dull. Opposite terms, not necessarily equal, are combined to create a clever new usage, like *thunderous silence* or *sweet sorrow*. If the formal definition is bent or skewed even more perversely, oxymorons can be found hiding throughout language. For example, it is possible to speak of *oral literature, flying fish,* or *dry ice*. Other examples are found in vernacular usages. Restaurant menus offer *jumbo shrimp* and car rental offices have rubber stamps reading *foreign local*. There are even one-word oxymorons such as *superette*, a commercial condensation which strangely means *a petite grandeur*.

Puns play through language at one phonetic remove, providing an opening or gap in language's structure through homophonous substitutions. Likewise, oxymorons liberate words from their traditional meanings by cross-referencing their usual referents. A new relation is established between two words whose individual connotations would seem to defy unity. Or the two words, used together, provide an entirely new logic. A crisis is produced in normal grammatical usage that is completely unexpected. However, the two words of the oxymoron do not cancel each other out; rather they generate a small gap between them, a playful space of freedom in the "prison house of language," as Nietzsche called it. Like back-to-back bookends without books, the new space is potent with suggestion.

An interest in oxymorons and puns always reflects a desire to break the bonds of language rules. If used subconsciously as accidents or mistakes, they are then available for the kind of analysis now associated with the famous "Freudian slip." Consciously used, oxymorons are part of the dynamics of the surrealistic, the illogical, the contradictory. Oxymorons "open" language, in the same way that Lautremont's "chance meeting upon a dissecting table of a sewing machine and an umbrella" presents a juxtaposition of disparate images and invites scrutiny of meaning. An oxymoron, then, loosens the regulatory boundaries and undermines the historical authority of correct language. An oxymoron questions the assumed logic of meanings.

Fig. 14

Gerhard Richter

Neger II (Negro II), 1965

Oil on canvas

60 x 72 in.

The Emily and Jerry Spiegel Collection,

Kings Point, New York

Why introduce the idea of an oxymoron here? What analogous relationship can be inferred between oxymorons and the issues addressed by art works in this exhibition? What is the equivalent of an oxymoron in the languages of painting and sculpture? This brief essay will attempt to tease out some of the implications of the work in this exhibition through this simple concept of (oxymoronic) rupture. It is not an attempt to circumscribe the intentions of the artists and their works but merely a suggestion of linguistic analogy, a suggestion of one mode of cognizing how the works in this exhibition *work*.

It is important to remember that no meanings (nor systems of constructing meanings) are essentially natural. Language is not a neutral process. It is not value free, but is quite the opposite, in fact. Words and sentence constructions are always part of a greater cultural system of values which constrains and determines the edges of their use. It is possible to see advertising as competition for the "believability" of one set of signs over another, politics as complex ritual in an environment of signs designed to produce another belief system. Both, for instance, use language(s) of signs with much the same roles for convincing an audience that symbols played in a religious past. Similarly, visual language(s) is equally a type of sign system(s) whose meanings are always socially produced and subject to interpretation and contestation.

It is possible then to see contemporary art as an environment of competing sign systems. In fact, most of the talk around contemporary art is based precisely on repeating this competitive idea: "believability" of one work, one artist, one school, one movement, one history, etc., over another. The conflict between *abstraction* and *figuration* is an exemplary case of such competition. Orthodox histories of recent modern visual art are pervaded by a set of oppositional dualisms such as conservative versus radical, accessible versus esoteric, expressive versus structural, bourgeois versus avant-garde, real versus imaginary, ordered versus chaotic, social versus individual, functional versus dysfunctional, high culture versus low, and even East versus West—in an iconographical cold war that places figuration in diametrical opposition to abstraction. Such dualities are both popular and elitist paradigms of contemporary art.

But recently, both language and painting have come to be seen as symbolic formations or sign systems. Therefore, the idea that one kind of language or painting can be so superior (so much more effective, so much more truthful, so much more universal) than another has been undermined or, at least, made more relative. The particular influence of Continental theories (mainly structuralist, post-structuralist, and deconstructionist) that concentrate on the way *systems* determine meaning—especially through language—have had an impact on artistic practices as well. In painting, as in language or as in any other symbolic formulation, the idea of truth to reference or the idea that a word or an image meant something fixed and stable, was undermined by the power and influence of these arguments. Writers such as Antonin Artaud, Georges Bataille, Raymond Roussel, and James Joyce attempted to break the historical assumption that language could tell the "truth," by deliberately revealing that language is composed of unfixed meanings. Truth and objectivity have then slowly given way to the hard-earned but disquieting understanding that all discursive activity is inscribed in constructed realities that are, in fact, systems of interpretation. All symbolic languages are understood to be unstable and unfixed in a field of signs that are conventionally and institutionally encoded, but which are also available for and even demand change and reinterpretation.

If these theories are accepted to any degree, they immediately change the terms of the "battle" between abstraction and figuration. A picture of a person or thing is now understood not as having a necessary relation to its referent, but rather as standing for something *because* we have cultural conventions for recognizing that which is depicted. (A line or a set of lines can never *be* a horse, but it is possible to *understand* the depiction of one because a history of depictions called horses from cave figures to animated cartoons to a drawing by Degas[1] have provided a sociological basis, a matrix for such understanding.) In other words, a figurative picture depends upon some degree of abstracting to be understood in relation to its referent (a real horse). As a symbolic construction of "the real," a picture depends on and demands a full complement of cognized arbitrary cultural traditions to make itself understood.

Similarly, abstract paintings as symbolic constructions of a concept of the invisible imaginary or of the sublime depend upon some "real" referent outside of themselves to be decipherable. Mostly, these references are already contained in

language. For instance, the psychological concept of angst exists before it is applied as an analogy associated with Expressionism; or the concepts of alienation and freedom exist as existential terms before they are applied to Abstract Expressionist pictures. Similarly, the values we associate with geometry, like order and rationality, exist previous to being linked to visual movements like Neo-Plasticism. In other words the "battle" between figurative or abstract references is not just a market device to keep the art world new and fresh (or neo-new and neo-fresh), but it also points to the fact that pictorial visuality in contemporary painting is constrained by those two poles. Both figuration and abstraction constitute the traditional parameters of visual representations in modern art. They are both representations. They both refer to something outside of themselves. They are both signs of other things as well as being signs of art. It is not just a question of a battle between figuration and abstraction then. Rather it is the idea of *representationality* that has been thrown into question in the twentieth century through both theory and practice.

If this idea of questioning or crisis in the expectations and nature of sign systems is accepted—even partially—it becomes clear that neither system of producing images has any inherent claim to validity greater than the other; both are symbolic constructions subject to values, formulations or protocols for referencing other values and information. Both are, in fact, representational. (Both systems are motivated by ideas of communication, and both are limited by culturally determined matrices of meaning.) Although a figurative picture might seem to refer to a person or event in the real world as a kind of duplication of it, it is actually an image construction that is understood in relation to histories and intertextual networks for comprehension. Although an abstract work might seem "empty" of direct meanings, it must in fact refer to a feeling or concept via already-known cultural meanings outside of the visual plane in order to be understood as something more than subjective or narcissistic expression.

Such positioning of antagonistic opposites (figuration versus abstraction), then, has neglected the oscillation between the two, has neglected the space that performs the difference, has neglected the unconscious affinity that joins the two in a coherent discourse called visual art. Within visual art there are these disputes, these polarities to the territory; but it is still a discourse that binds them together in a conventional pattern, each relying on the presence of the other to exist in a never-ending battle for succession to the throne of visual propriety and property. The forced dialectic of opposites and dualisms has hidden the mutual disposition, the reliance and collusion, which makes of figuration and abstraction a regulated and "correct" discourse. This is most obvious in, but not exclusive to, painting.

In other words, there is an inevitable coherency between figuration and abstraction despite the familial battles over them precisely because each is part of a larger discourse. In the same way that language usages must always be fresh-yet-practical to both the speaker and the listener, so does any given usage always refer to the enduring-yet-malleable principles of language (its grammar, its syntax, and so on). This larger encompassing discourse in the visual arts—its enduring quality—might be called *ocular*, which refers to the strict dependence on the eye as the privileged sense of truth and knowledge. In our culture, the other senses (hearing, touching, tasting, smelling) have been short-circuited by a reliance on the visual as the primary information base for knowledge. It is a cultural bias that is both modern and Western. To privilege eyesight means simply to use visual methods and technologies of vision over and above the other senses in formulating the belief systems of, for instance, science or art. This ocular discourse, including the written word, is the larger system that has been put into question in the modernist work, which demonstrates visuality and language to be relative systems. The ocular system might be said to be the *deep structure* of both painting and literature. From the inclusion of "real" materials into the picture plane (already mentioned in Cubist work) to the inclusion of industrial materials in Duchamp's readymades in the early part of the century, to the performance, video, and diverse media practices of today, artists have attempted radically to undermine the primacy of the ocular discourse through the introduction of other sensory elements and social connotations.

If a linguistic analogy can be useful (without being too reductive), it is because visual art and artists, like theoreticians, have equally participated in this larger attempt to question the governing aspect of visual language's uses. If this unity or coherence that any "correct" language attempts to impose on reality is under consideration everywhere—especially in the twentieth century—it is possible to see how that theory has also been deeply

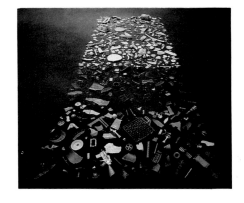

Fig. 15

Tony Cragg

Newton's Tone-New Stones, 1982

Plastic floor construction

197 x 72 in.

Courtesy of Marian Goodman Gallery, New York

Fig. 16
Wallace & Donohue
Jack in the Box (Five Easy Pieces), 1987
Mixed media
72 x 60 x 17 in.
Photo courtesy of Postmasters Gallery, New York

and originally influenced by a parallel questioning in the visual arts. Many modernist movements from Impressionism onward have also shown how visuality, i.e., the visual language of art, is constructed. For example, Cubist collage archetypally fractured, splintered, or deconstructed the picture plane, and Cubist constructions had the same impact on the "realism" of the sculptural space. The result in both instances was to reveal the arbitrary nature of Renaissance illusionism, whose schema was often historically argued as "natural." The linguistic theory that is so influential today was itself originally based on analyses of modernist practices in both literature and the visual arts.

The formalist histories of modernism, which until recently dominated much thinking about art, repress the material, nonocular differences to a large degree. And it is easy to see how this happens, because text and image (printed word and photograph which themselves are a part of visual primacy) are privileged in the dissemination of information about art through magazines, books, and catalogues as well as through more specifically educative slides and films. Most art work that is not ocular is therefore reclaimed under the rubric "visual art." Such art is assimilated into the visual text. The smells of works by Joseph Beuys or Wolfgang Laib, the temporal elements of performance and video, the sound of a Rebecca Horn mechanism or a Bill Viola installation, the feel of early Greek ceramics, or the textures and smells of the rubber curtains of Izhar Patkin are all quickly repressed in any discourse that is dependent upon the eyes. Text and photograph conspire to reduce or negate the complexity of the experience of such works. An ocular system still dominates the methods of distributing knowledge about the arts. This exclusion of other sensualities, then, becomes the limit of a linguistic analogy for objects—even for the liberating analogy of the oxymoron, since it too can simply be returned to textual meanings and ignore the materials, thereby failing to treat the psychological import of many of the works in the exhibitions.

The insidious nature of "visuality" or the ocular discourse (the network of discursive practices, technologies, and institutions that make things visible) has been addressed especially by French and Canadian theorists. The French preoccupation with "le regard" or "the gaze" culminates in Michel Foucault's preoccupation with the *voir* in *pouvoir* and *savoir* (the "seeing" that is included in power and knowledge). The work of Canadian theorists Harold Innis and Marshall McLuhan on sensory extensions and deprivations has also been an attempt to uncover the deep and manipulative implications of an ocular discourse that creates the "empire of the gaze."[2] It is the contention of these and other theoreticians that an emphasis on the eye (I) has created an environment that accepts technological and social surveillance devices, and thus the centralization of power. By reducing visual art to formalist terms, it is clear that criticism and art history participate in the descriptive control that results from an ocular emphasis, that it imposes the same kind of authoritarian control over art. But if the art itself deliberately cross-references vision or makes vision problematic by an (oxymoronic) rupture of the figurative/abstraction debate, it may find a way (however temporarily) out of the purely ocular and out of formalist reductions.

Some artists in this exhibition deal with the problems associated with the ocular discourse, and they do it without using the previously mentioned more radical material practices of going outside the ocular discourse to develop new forms. Instead, they participate from *within* tradition itself by bridging the false antagonism between figuration and abstraction. *Rather than trying to continue an avant-garde agenda of introducing the other senses through experimental forms, these works try to act subversively from within the deeper structure of ocularity itself.* Particularly pertinent examples of this initiative among the younger generation of 1980s artists are Rosemarie Trockel, Wallace & Donohue, Haim Steinbach, Ross Bleckner, Christopher Wool, Diana Formisano, Judy Pfaff, Annette Lemieux, and Andres Serrano. The antagonistic dichotomies of modernist history, outlined above, are posed conflictingly *within single works* to disclaim the sovereignty of either representational (visual) mode.

The works are not overtly avant-garde then, as are the video installations of Viola or the theaters of Patkin, which attempt to undermine the structural basis of the modernist visual knowledge itself. Artists in this exhibition have chosen the more modest but important project of working from within the neglected space of pictorial modernism, in the oxymoronic rupture of the figurative and abstract poles. At this specific moment in historical consciousness, these works

probe the so-called contradiction between abstraction and figuration by making visible its actual coherence. The work here does not reconcile these posed differences but rather foregrounds them to establish a revitalization of the modernist project itself, just at the moment that modernism's death is being confidently announced. With shifts in materials and procedures, most notably the use of commodity objects in low relief as well as photographic images (with their attendant narrative histories), the ocular discourse is re-presented with the false exclusivity of its dualities exposed. The descriptive control associated with either abstraction or figuration is freed in favor of a paradoxical image.

Precedents for this work date back to the 1960s and 1970s and announce the theme pursued here. The recent work of this younger generation is heralded by the paintings of Gerhard Richter, for instance (see fig. 14; pls. 33, 34 and cover). His painterly career has been distinguished by an oppositional dialectic of paintings made of details from kitsch romantic figurative paintings, posed against paintings made of details from kitsch romantic abstract paintings. Richter's work depends upon and critically comments on the dichotomies of simulated opposition between figuration and abstraction. Because Richter's paintings are initially painted from photographs, he also highlights the role of photography in mediating the "difference" between the two.

Throughout his career, which began in the 1960s, Artschwager has similarly reframed the formal considerations of abstraction within figurative objects and images. His images (which, like Richter's, are based on photographs) as well as his objects comment simultaneously on the space between the two poles of the ocular discourse (see pls. 1, 2, 3). The wry humor and irony in his work inform the emotional distance of the next generation's work. In the case of Richter and Artschwager, the absence or space between the two poles is the implied subject.

This space is apparent in Tony Cragg's use of cultural materials, such as found fragments of plastic, as the material base of his sculptural images (see fig. 15; pls. 11, 12). Cragg followed Richard Long's minimal methods of walking into nature and bringing back "memories" of it, but, importantly, Cragg used the city as nature and his memories were the cultural detritus of the streets. By taking these parts to make up an image, Cragg compressed the fragments into another connotation. The bits and pieces, which are mostly abstract, become part of a whole that is figurative. Cragg is a 1970s artist who acts as a transitional figure between the two generations represented here. It is possible to say that these three artists, among others, set the pendulum between abstraction and figuration in motion.

For most of the younger artists in this exhibition, the extremities of the figurative/abstract paradigm, such as the work of Cragg, are condensed into one work, attacking the subject directly. A few examples will clarify. In a Wallace & Donohue work called *Jack in the Box (Five Easy Pieces)* (fig. 16, not in the exhibition), a series of box-like wooden structures are stacked. The empty ones establish the abstract pole as they are reminiscent of Donald Judd's "objects" and imply his rhetoric for

the ideal purity of functionless art. They are ironically underscored by a large partitioned photograph of the actor, Jack Nicholson, wearing his ever-present sunglasses, which references simultaneously the figurative pole and the concept of vision. Two seemingly disparate ocular strains (the art industry and the promotional industry, two well paid "bad boys"—which is how Nicholson himself is often cast) are brought together in a sweet collision whose endless pairings of parallel connotations reverberate into imaginative infinity.

From a distance, Rosemarie Trockel's two-dimensional works seem to have all of the subtle elements of, for example, Rothko's lyrical abstract painting (see pls. 42, 43). But the purity of the sublime, which we associate with this genre, is denied on closer visual and *tactile* inspection. Abstraction's authority is deliberately warped because the surface is actually an industrially woven fabric that gives no evidence of an artist's "touch." And the visual aura is exposed to be a composition of logos or symbols—or even texts—from the world of commerce and advertising. Through her laconic juxtapositions, the corporation and the museum are conjoined as equivalent institutions of the visual arts discourse. Trockel's investigation simply undermines an educated viewer's expectations of the abstract sublime by beautifully demonstrating its relation to design and power today.

Christopher Wool's interrogation of this neglected modernist space is similarly playful and serious. Wool often paints with a rubber painting roller that has designs already cut into it; a cheap tool for simulating wallpaper (see fig. 17; pls. 48, 49). Painting with this mass-produced decorator's device, he too avoids visual art's investment in painterly and individual touch. He deliber-

Fig. 17

Christopher Wool

Untitled, 1987

Alkyd on aluminum and steel

72 x 48 in.

Collection of the artist,

Courtesy of Luhring Augustine Gallery, New York

ately produces "accidents," which convey the true impression that the works are special hand-made objects. But in a quick and simultaneous reversal, they are also, oxymoronically speaking, *printed paintings*—machine-made traces. And the "image" is still there (floral or geometric), stubbornly available as figuration and connotation in spite of its abstracting. The ironic interplay between figure and ground, black and white, machine and hand, nature and culture maintains each referent simultaneously; each is recirculating in an endless Moebius strip of interrelatedness which makes visual separation and conceptual opposition impossible.

Yve-Alain Bois has argued that such recent work, which would include much that is not exhibited here, is once again rehearsing the death instinct inherent in all modernism and emblemized through painting in particular.[3] By death instinct, he means that modernism's abstract reductionisms from Malevich's "last" paintings to Reinhardt's "last" paintings act as a continually revised announcement of the end of art—or, at least, the end of painting; in each case, time and time again, painting is reduced to a point of perfection that will preclude further painting. Such a construct of modernist art's continual affirmation of its own end is parallel to Foucault's sense of the objectifying power of the biological gaze finding death at its heart, to Innis and McLuhan's equally medical sense that to privilege eyesight was to reify all other sense activity at a great expense and deprivation to the body politic. All these positions suggest, as the myth of Medusa itself, that there is death at the core of the ocular discourse, that vision fixes or freezes forever some aspect of the vital, the living.

There is, however, some hope in spite of the apocalyptic persuasiveness of these arguments. Just as Surrealism was able for a sustained time to open a door of perception through ocular fixation (cf., the cutting of the eye in Salvador Dali and Luis Buñuel's movie *Le Chien Andalou*), the artists mentioned above are again prying open a legitimate but paradoxical space in the modernist visual discourse. This might more appropriately be called a debt instinct, an intuition of the continuing meaningfulness of the modernist project itself. Although the eventual results of this investigation will continue to declare themselves as neither abstraction nor figuration, nor, for that matter, as painting or sculpture, there is here the recognition that the ocular discourse is not one of pure negativity, with art works as obituaries. The deliberate paradoxes encountered here are, in fact, the impure agents of modest, but significant, revitalization; a hybrid hope for a future not yet defined. ∎

1. This example is given by Umberto Eco, *A Theory of Semiotics* (Bloomington: Indiana University Press, 1979), under a discussion of sign-functions; and again a horse appears prominently in the beginning of his novel *The Name of the Rose*, which is a popular version of his academic theories.
2. The best gloss on this tradition is still Arthur Kroker, *Innis/McLuhan/Grant: Technology and the Canadian Mind* (Montreal: New World Perspectives, 1984). For a fuller discussion of the "ocular" discourse in French thought, see Martin Jay, "In the Empire of the Gaze: Foucault and the Denigration of Vision in 20th Century French Thought," in *Postmodernism*, ed. Lisa Appignanesi, Institute of Contemporary Arts Documents, vols. 4-5 (London: Institute of Contemporary Arts, 1986).
3. Bois, Yve-Alain, "Painting: The Task of Mourning," in *Endgame: Reference and Simulation in Recent Painting and Sculpture*, ed. David Joselit and Elizabeth Sussman (Boston: Institute of Contemporary Art, 1986).

Illustrations

Pl. 1
Richard Artschwager
Book, 1987
Formica on wood
5 1/16 x 21 1/8 x 12 1/16 in.
Courtesy of Leo Castelli Gallery, New York

Pl. 2
Richard Artschwager
Four Dinners, 1987
Formica, Celotex, acrylic paint and wood
60 x 186 x 29 1/2 in.
Courtesy of Leo Castelli Gallery, New York

Pl. 3
Richard Artschwager
Weave Drape, 1971
Acrylic on Celotex
39 3/4 x 53 in.
Collection of Richard and Lois Plehn, New York

Pl. 4
Ross Bleckner
Architecture of the Sky III, 1988
Oil on canvas
106 x 92 in.
Collection of Elaine and Werner Dannheisser,
New York

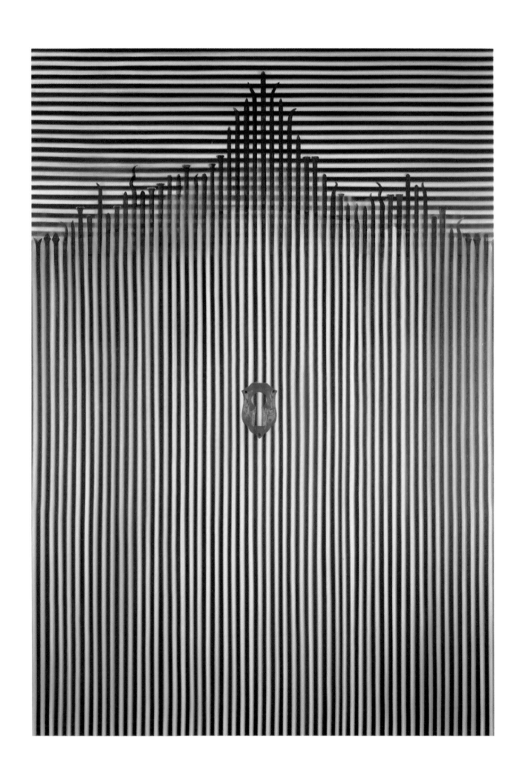

Pl. 5

Ross Bleckner

Gate #2, 1986

Oil on canvas

120 x 84 in.

Collection of Norman and Irma Braman,

Miami

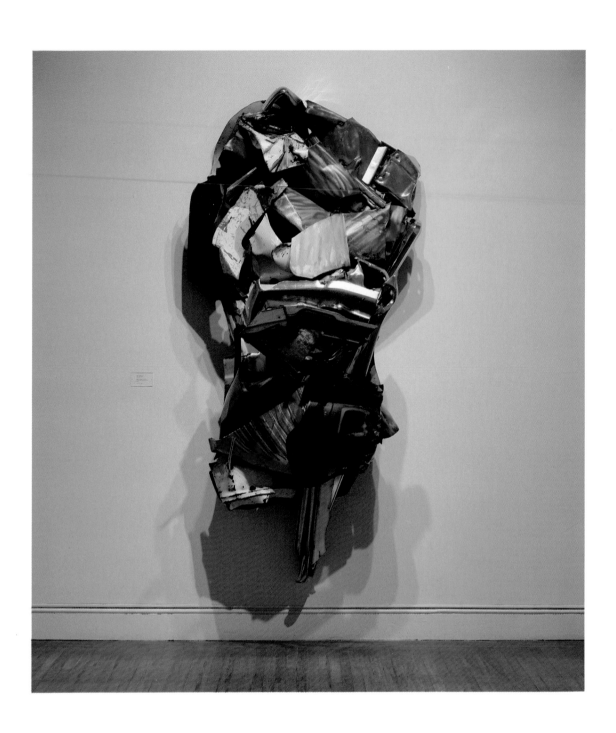

Pl. 6
John Chamberlain
Added Pleasure, 1975-1982
Painted and chromium plated steel
111 x 53 x 36 in.
The John and Mable Ringling
Museum of Art, Sarasota, Florida

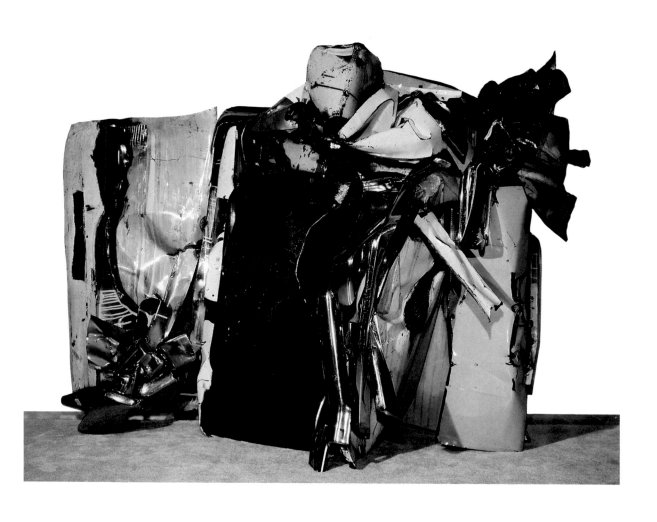

Pl. 7

John Chamberlain

Wandering Bliss Meets Fruit of the Loom
(America on Parade), 1980

Painted and chromium plated steel

71 x 112 x 43 in.

Collection of Mr. and Mrs. Sydney Adler,

Sarasota, Florida

Pl. 8
Sarah Charlesworth
Maps, 1987
Laminated Cibachrome and lacquer frame
41 x 61 1/4 in.
Collection of Fried, Frank, Harris, Shriver & Jacobson,
New York

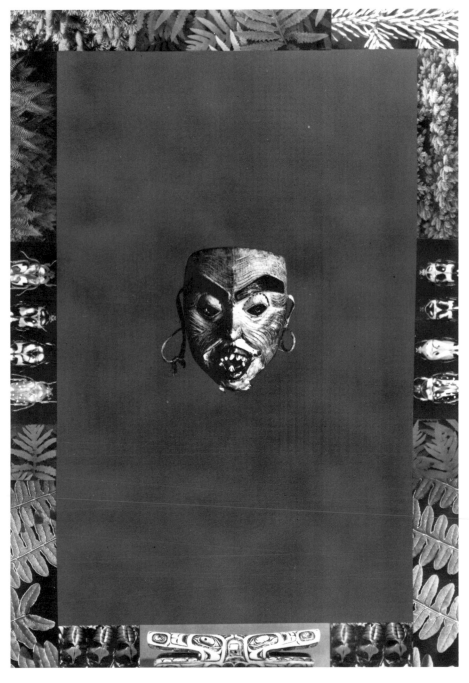

Pl. 9
Sarah Charlesworth
Green Mask, 1986
Laminated Cibachrome and lacquer frame
40 x 30 in.
Courtesy of Jay Gorney Modern Art,
New York

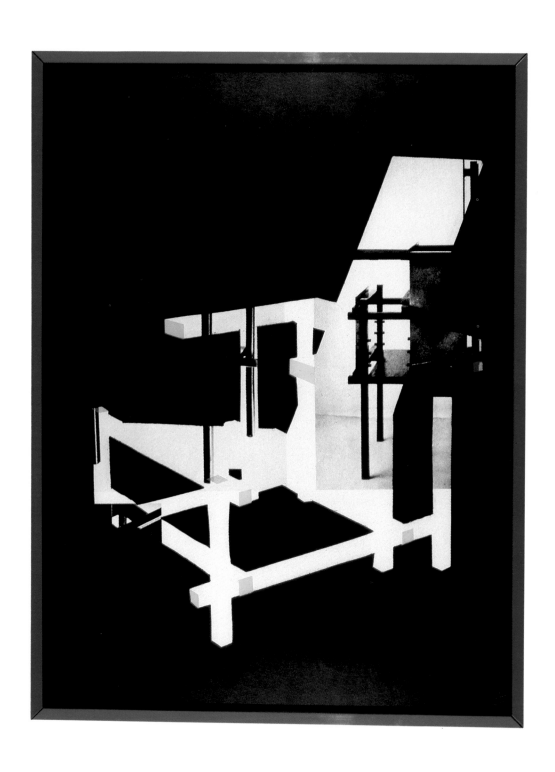

Pl. 10

Sarah Charlesworth

Rietveld Chair, 1981

Laminated Cibachrome and lacquer frame

67 x 50 in.

Collection of Michael Schwartz, New York

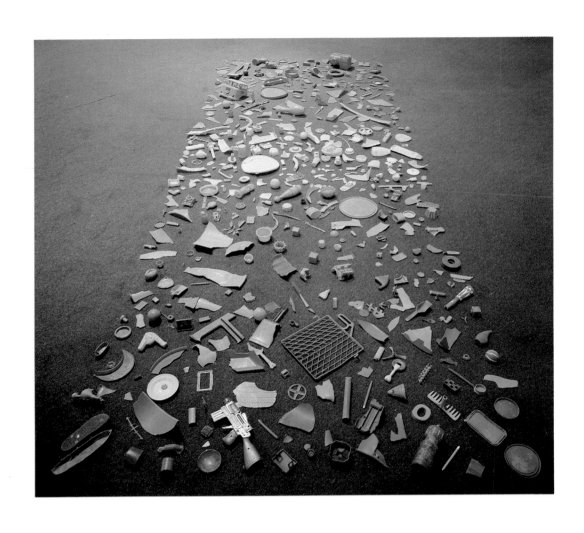

Pl. 11

Tony Cragg

Newton's Tone-New Stones, 1982

Plastic floor construction

197 x 72 in.

Courtesy of Marian Goodman Gallery,

New York

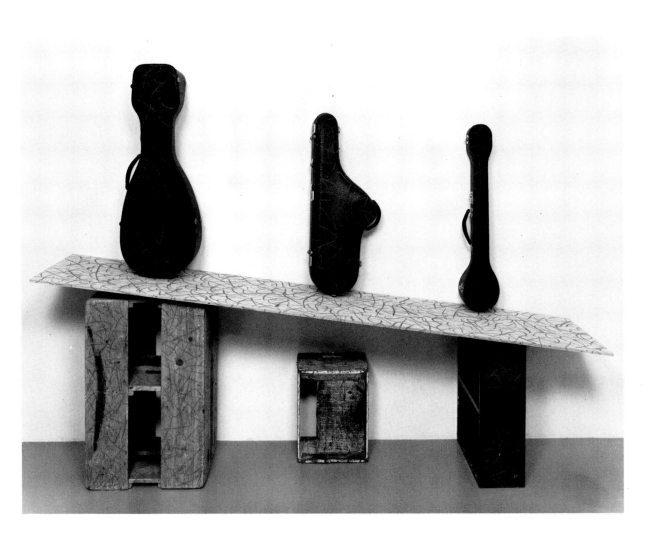

Pl. 12
Tony Cragg
Blue Drawing, 1984
Wood and musical instrument cases and
drawing with crayon
69 x 96 x 24 in.
Collection of Anne and Martin Z. Margulies,
Miami

Pl. 13

Carroll Dunham

Fifth Pine, 1984-1985

Mixed media on pine

62 x 40 in.

Collection of Ellen and Ellis Kern,

New York

Pl. 14

Carroll Dunham

Transit, 1986-1987

Mixed media on maple veneer

78 x 39 in.

Collection of Linda and Harry Macklowe,
New York

Pl. 15
Diana Formisano
Aggregate, 1987
C-prints and black-and white photographs,
Plexiglas, wood and Formica
78 x 51 x 4 1/2 in.
Courtesy of Postmasters Gallery, New York

content

Pl. 16

Diana Formisano

Red Cross, 1987

Black-and-white photographs-photograms,

Plexiglas, wood and Formica

33 1/2 x 33 1/2 x 4 in.

Private Collection, New York

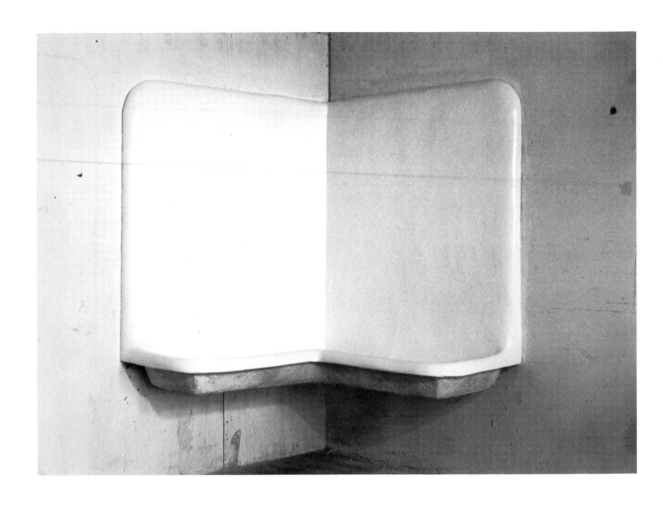

Pl. 17
Robert Gober
The Scary Sink, 1985
Plaster, wood, steel, wire lath and
semi-gloss enamel
60 x 78 x 55 in.
Collection of Edward R. Downe, Jr.,
New York

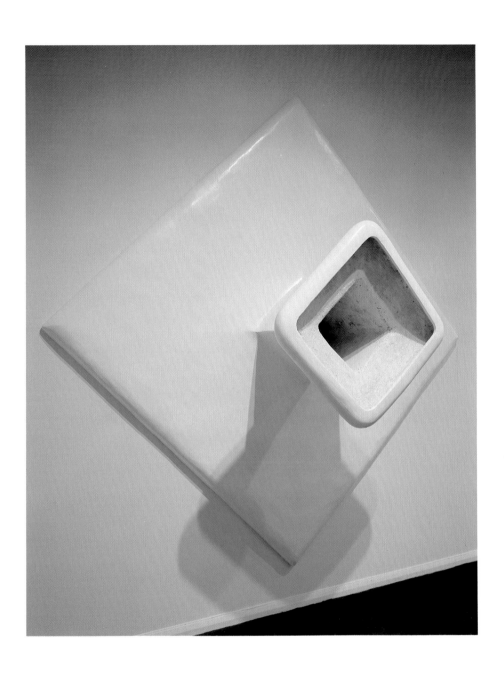

Pl. 18
Robert Gober
The Kaleidoscopic Sink, 1985
Plaster, wood, steel, wire lath and
semi-gloss enamel
100 x 100 x 24 in.
Collection of Edward R. Downe, Jr.,
New York

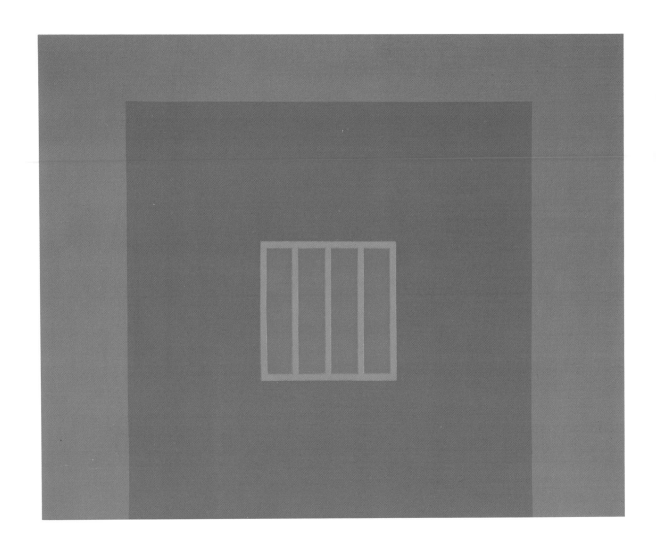

Pl. 19
Peter Halley
Day-Glo Prison, 1982
Day-Glo acrylic and Roll-a-Tex on canvas
63 x 77 in.
The Emily and Jerry Spiegel Collection, Kings Point, New York

Pl. 20
Peter Halley
Gray to Black, 1988
Acrylic on canvas
62 x 128 in.
Collection of Joseph E. McHugh, Chicago

Pl. 21

Ronald Jones

Untitled (Plan for Erich Mendelsohn's Columbushaus, 1932, which housed an
SS concentration camp between 1933 and 1936, Potsdamer Platz, Berlin.
Verso: woodcut, by an anonymous inmate depicting a scene in the
Columbushaus concentration camp, 1934), 1988
Purpleheart, white maple, harewood, ink,
annodized aluminum and steel
Installation view at Metro Pictures, New York, November 12-December 10, 1988

Pl. 22

Ronald Jones

Untitled (Plan for Erich Mendelsohn's Columbushaus, 1932, which housed an SS concentration
camp between 1933 and 1936, Potsdamer Platz, Berlin. Verso: woodcut, by an anonymous
inmate depicting a scene in the Columbushaus concentration camp, 1934), 1988
Purpleheart, white maple, harewood, ink,
annodized aluminum and steel
Detail of the installation in pl. 21, 85 x 48 x 25 in.
Courtesy of Metro Pictures, New York

Pl. 23
Ronald Jones
Untitled (Peace Conference Table Designs for 1969 Paris Peace Conference), 1987
Painted wood and transfer tape
16 x 216 x 2 2/3 in. installed
Collection of Henry Newman, New York
Installation consisting of seven parts

Untitled (Peace Conference Table Design by North Vietnam and The National Liberation Front of South Vietnam, 1969), 1987
One part, 16 in. diameter
Untitled (Peace Conference Table Designs by the United States and South Vietnam, 1969), 1987
Six parts, each 16 in. diameter

Pl. 24
Annette Lemieux
The Human Comedy, 1987
Oil and graphite on canvas
102 x 78 in.
Collection of Arthur and Carol Goldberg,
New York

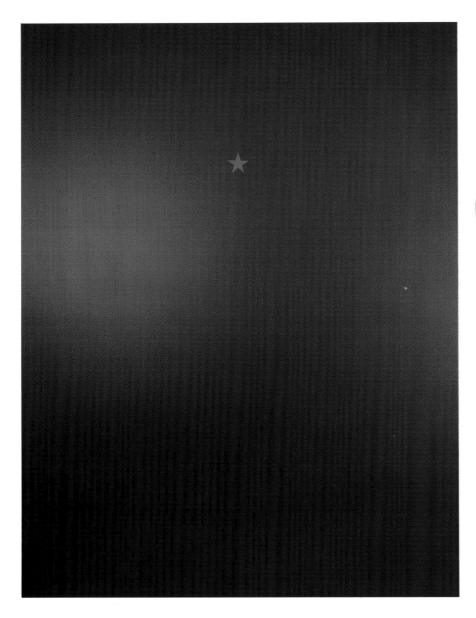

Pl. 25

Annette Lemieux

Vacancy, 1986

Oil on canvas and frame with glass

92 x 72 in.

Collection of Colombe and Leonard Rosenberg,

Courtesy of Josh Baer Gallery, New York

Pl. 26
Roy Lichtenstein
Brushstroke Chair and Ottoman, 1988
Cast bronze
Chair, 70 3/4 x 18 x 26 3/4 in.
Ottoman, 20 1/2 x 18 x 23 1/2 in.
University of South Florida Collection, Courtesy USF Art Museum,
Tampa

Pl. 27
Roy Lichtenstein
Paintings: Abstractions, 1984
Oil and Magna on canvas
70 x 80 in.
Private Collection, New York

Pl. 28
Elizabeth Murray
Slip Away, 1986
Oil on canvas
129 1/2 x 101 1/2 x 9 in.
Private Collection, New York

Pl. 29

Elizabeth Murray

The Garage, 1985

Oil on three canvases

60 x 86 1/2 x 14 in.

Collection of Jennifer Bartlett, New York

Pl. 30

Judy Pfaff

Brooklyn Notebook, 1986

Mixed adhesive plastics on graph paper

46 x 80 in.

Collection of Eric Rudin, New York

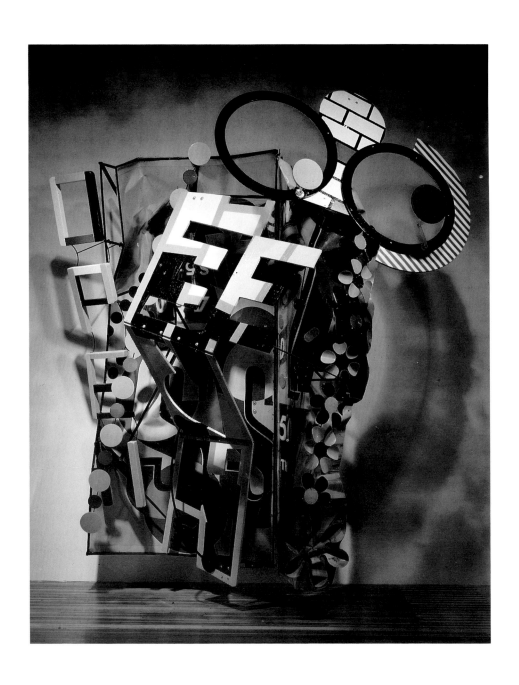

Pl. 31
Judy Pfaff
Great Glasses, 1988
Mixed media
108 x 96 x 60 in.
Courtesy of Holly Solomon Gallery, New York

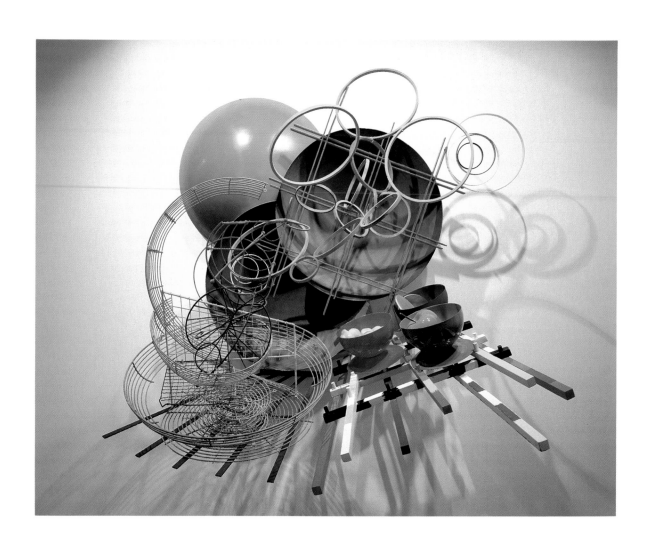

Pl. 32

Judy Pfaff

Suzie-Q, 1986

Mixed media

55 x 61 x 40 in.

Collection of Randolfo Rocha, Boston

Pl. 33

Gerhard Richter

Still, 1986

Oil on canvas

88 1/2 x 78 3/4 in.

Collection of Raymond J. Learsy, Sharon, Connecticut

Pl. 34

Gerhard Richter

Neger II (Negro II), 1965

Oil on canvas

60 x 72 in.

The Emily and Jerry Spiegel Collection, Kings Point, New York

Pl. 35
Andres Serrano
Circle of Blood, 1987
Cibachrome print
30 x 46 in.
Courtesy of Stux Gallery, New York

Pl. 36
Andres Serrano
Milk, Blood, 1986
Cibachrome print
30 x 40 in.
Courtesy of Stux Gallery, New York

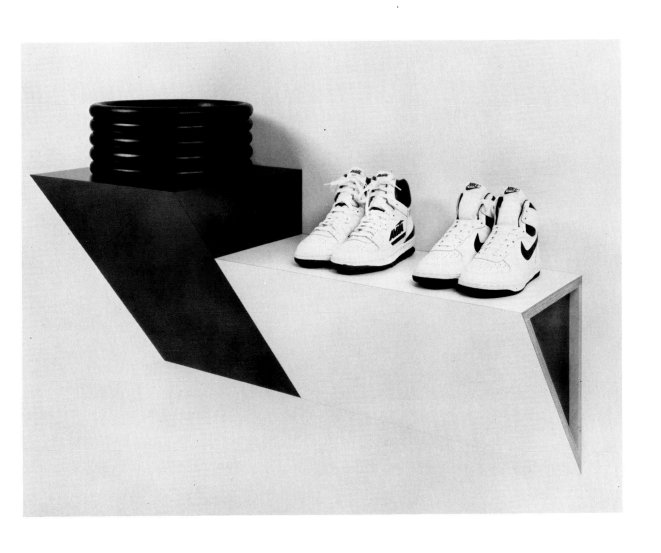

Pl. 37

Haim Steinbach

no wires, no power cord, 1986

Mixed media construction

29 x 46 1/2 x 18 1/2 in.

Collection of Elisabeth and Ealan Wingate, New York

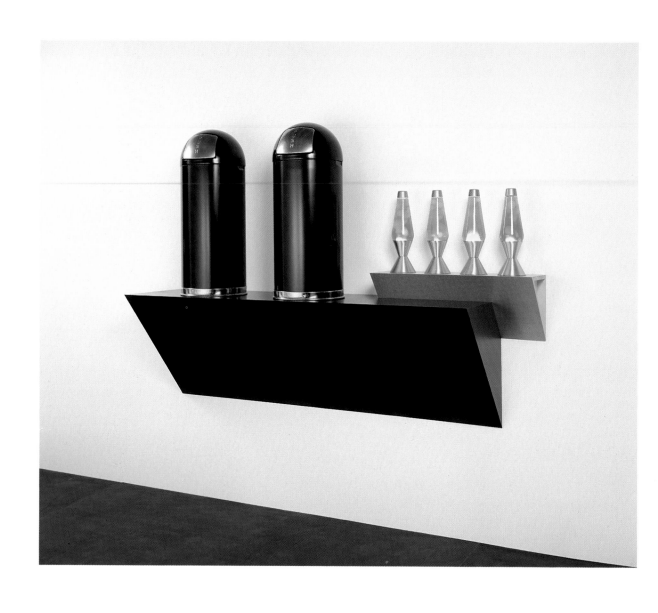

Pl. 38
Haim Steinbach
00:06 (2,4L), 1988
Mixed media construction
30 1/2 x 90 1/8 x 21 in.
Courtesy of Jay Gorney Modern Art and Sonnabend
Gallery, New York

Pl. 39
Philip Taaffe
Strangulation with Necktie, 1986
Linoprint, collage and acrylic on paper
22 1/4 x 14 1/4 in.
Collection of Peter Brams, Guttenberg, New Jersey

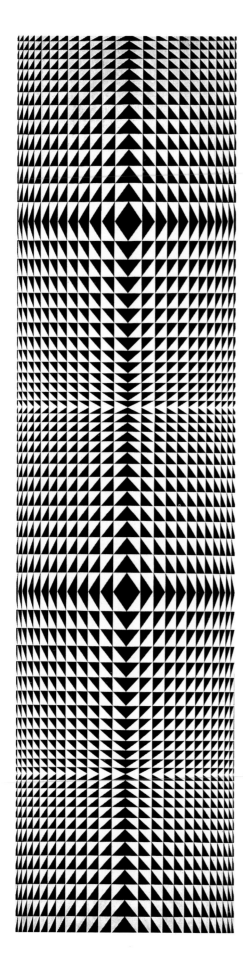

Pl. 40

Philip Taaffe

Pharos, 1985

Silkscreen, collage and acrylic on paper

140 1/4 x 36 in.

Collection of Donald and Mera Rubell, New York

Pl. 41
Philip Taaffe
Polygon, 1987
Silkscreen, collage and acrylic on canvas
55 x 70 in.
Collection of Mr. and Mrs. Robert Sosnick, Bloomfield Hills, Michigan

Pl. 42

Rosemarie Trockel

Untitled (hammer and sickle flag), 1986

Knitted wool, stretched

59 x 51 1/4 in.

Collection of Carol and Paul Meringoff,

New York

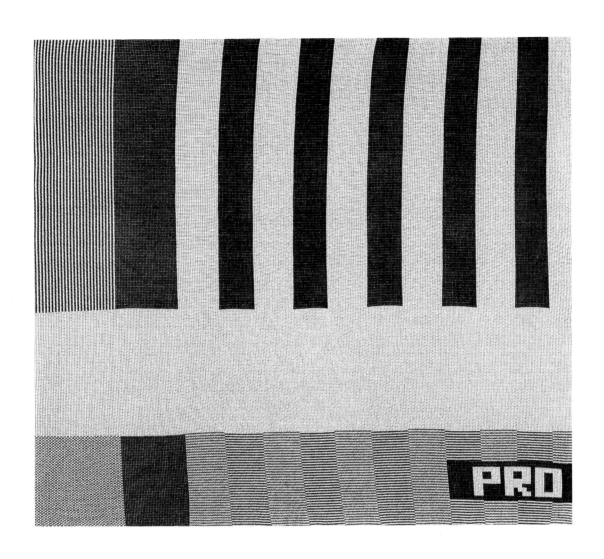

Pl. 43
Rosemarie Trockel
Untitled, 1986
Knitted wool, stretched
57 x 65 in.
Courtesy of Barbara Gladstone Gallery, New York

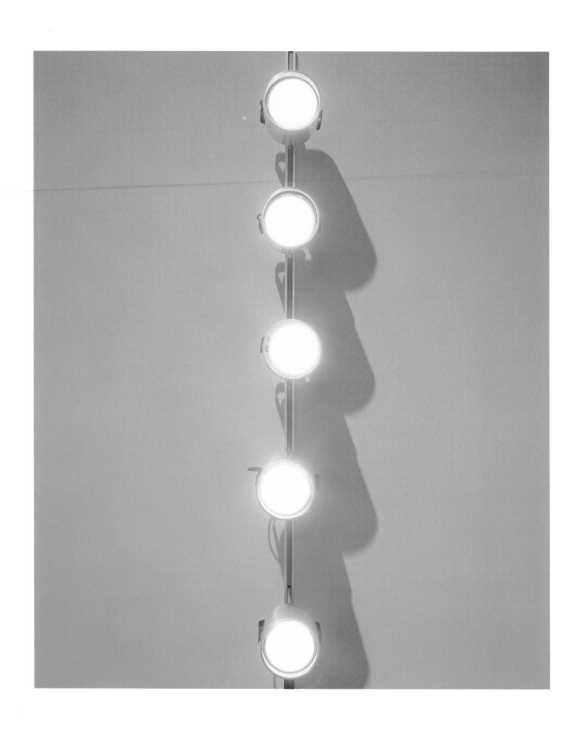

Pl. 44

Wallace & Donohue

Star Search (The Light Painting), 1987

Latex on canvas with five track lights

72 x 60 x 29 1/2 in.

Tony Shafrazi Gallery, New York

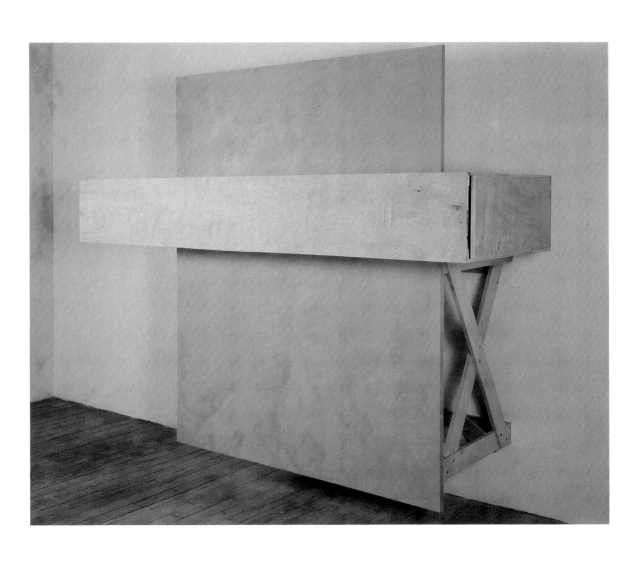

Pl. 45

Wallace & Donohue

The Artist Disappears, 1987

Latex on canvas with wood

72 x 84 x 45 in.

Collection of Michael Schwartz, New York

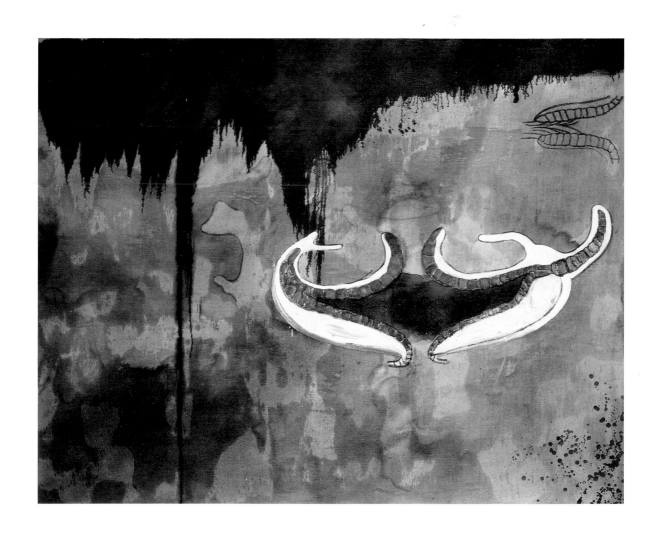

Pl. 46
Terry Winters
Jew's Pitch, 1986
Oil on linen
81 x 166 in.
Private Collection, New York

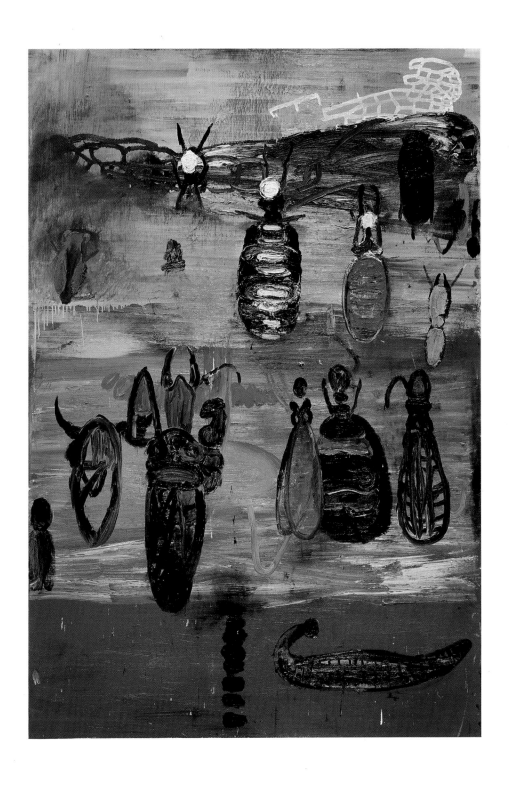

Pl. 47

Terry Winters

Insecta, 1985

Oil on linen

102 x 69 in.

Collection of Antonio Homem,

Courtesy of Sonnabend Gallery, New York

Pl. 48
Christopher Wool
Untitled, 1987
Alykd on aluminum and steel
72 x 48 in.
Collection of the artist,
Courtesy of Luhring Augustine Gallery, New York

Pl. 49
Christopher Wool
Untitled, 1987
Alkyd on aluminum and steel
72 x 48 in.
Collection of the artist,
Courtesy of Luhring Augustine Gallery, New York

WORKS IN THE EXHIBITION

Dimensions for all of the following works are in inches, with height preceding width preceding depth. All of the works are reproduced alphabetically by artist in the illustration section above, unless noted otherwise.

Richard Artschwager
Envelopes, 1966
Acrylic on Celotex
21 x 26
Private Collection, New York
(fig. 9)

Richard Artschwager
Weave Drape, 1971
Acrylic on Celotex
39 3/4 x 53
Collection of Richard and Lois Plehn, New York

Richard Artschwager
Book, 1987
Formica on wood
5 1/16 x 21 1/8 x 12 1/16
Courtesy of Leo Castelli Gallery, New York

Richard Artschwager
Four Dinners, 1987
Formica, Celotex, acrylic paint and wood
60 x 186 x 29 1/2
Courtesy of Leo Castelli Gallery,
New York

Ross Bleckner
Gate #2, 1986
Oil on canvas
120 x 84
Collection of Norman and Irma Braman,
Miami

Ross Bleckner
Architecture of the Sky III, 1988
Oil on canvas
106 x 92
Collection of Elaine and Werner Dannheisser,
New York

John Chamberlain
*Wandering Bliss Meets Fruit of the Loom
(America on Parade)*, 1980
Painted and chromium plated steel
71 x 112 x 43
Collection of Mr. and Mrs. Sydney Adler,
Sarasota, Florida

John Chamberlain
Added Pleasure, 1975-1982
Painted and chromium plated steel
111 x 53 x 36
The John and Mable Ringling
Museum of Art, Sarasota, Florida

Sarah Charlesworth
Rietveld Chair, 1981
Laminated Cibachrome and lacquer frame
67 x 50
Collection of Michael Schwartz, New York

Sarah Charlesworth
Green Mask, 1986
Laminated Cibachrome and lacquer frame
40 x 30
Courtesy of Jay Gorney Modern Art,
New York

Sarah Charlesworth
Maps, 1987
Laminated Cibachrome and lacquer frame
41 x 61 1/4
Collection of Fried, Frank, Harris, Shriver
& Jacobson, New York

Tony Cragg
Newton's Tone-New Stones, 1982
Plastic floor construction
197 x 72
Courtesy of Marian Goodman Gallery,
New York

Tony Cragg
Blue Drawing, 1984
Wood and musical instrument cases and
drawing with crayon
69 x 96 x 24
Collection of Anne and Martin Z. Margulies,
Miami

Carroll Dunham
Fifth Pine, 1984-1985
Mixed media on pine
62 x 40
Collection of Ellen and Ellis Kern,
New York

Carroll Dunham
Transit, 1986-1987
Mixed media on maple veneer
78 x 39
Collection of Linda and Harry Macklowe,
New York

Diana Formisano
Aggregate, 1987
C-prints and black-and white photographs,
Plexiglas, wood and Formica
78 x 51 x 4 1/2
Courtesy of Postmasters Gallery,
New York

Diana Formisano
Red Cross, 1987
Black-and-white photographs-photograms,
Plexiglas, wood and Formica
33 1/2 x 33 1/2 x 4
Private Collection, New York

Robert Gober
The Scary Sink, 1985
Plaster, wood, steel, wire lath and
semi-gloss enamel
60 x 78 x 55
Collection of Edward R. Downe, Jr.,
New York

Robert Gober
The Kaleidoscopic Sink, 1985
Plaster, wood, steel, wire lath and
semi-gloss enamel
100 x 100 x 24
Collection of Edward R. Downe, Jr.,
New York

Peter Halley
Day-Glo Prison, 1982
Day-Glo acrylic and Roll-a-Tex on canvas
63 x 77
The Emily and Jerry Spiegel Collection,
Kings Point, New York

Peter Halley
Gray to Black, 1988
Acrylic on canvas
62 x 128
Collection of Joseph E. McHugh, Chicago

Ronald Jones
*Untitled (Plan for Erich Mendelsohn's Columbushaus,
1932, which housed an SS concentration camp between
1933 and 1936, Potsdamer Platz, Berlin. Verso:
woodcut, by an anonymous inmate depicting a scene in
the Columbushaus concentration camp, 1934)*, 1988
Purpleheart, white maple, harewood, ink,
annodized aluminum and steel
Three parts, each 85 x 48 x 25
Courtesy of Metro Pictures, New York

Ronald Jones
*Untitled (Peace Conference Table Designs for 1969 Paris
Peace Conference)*, 1987
Painted wood and transfer tape
16 x 216 x 2 2/3 installed
Collection of Henry Newman, New York

Installation consisting of seven parts
*Untitled (Peace Conference Table Design by North
Vietnam and The National Liberation Front of South
Vietnam, 1969)*, 1987
One part, 16 inches diameter

*Untitled (Peace Conference Table Designs by the United
States and South Vietnam, 1969)*, 1987
Six parts, each 16 inches diameter

Annette Lemieux
Vacancy, 1986
Oil on canvas and frame with glass
92 x 72
Collection of Colombe and Leonard Rosenberg
Courtesy of Josh Baer Gallery, New York

Annette Lemieux
The Human Comedy, 1987
Oil and graphite on canvas
102 x 78
Collection of Arthur and Carol Goldberg, New York

Roy Lichtenstein
Paintings: Abstractions, 1984
Oil and Magna on canvas
70 x 80
Private Collection, New York

Roy Lichtenstein
Brushstroke Chair and Ottoman, 1988
Cast bronze
Chair, 70 3/4 x 18 x 26 3/4
Ottoman, 20 1/2 x 18 x 23 1/2
University of South Florida Collection,
Courtesy USF Art Museum,
Tampa

Elizabeth Murray
The Garage, 1985
Oil on three canvases
60 x 86 1/2 x 14
Collection of Jennifer Bartlett, New York

Elizabeth Murray
Slip Away, 1986
Oil on canvas
129 1/2 x 101 1/2 x 9
Private Collection, New York

Judy Pfaff
Brooklyn Notebook, 1986
Mixed adhesive plastics on graph paper
46 x 80
Collection of Eric Rudin, New York

Judy Pfaff
Suzie-Q, 1986
Mixed media
55 x 61 x 40
Collection of Randolfo Rocha, Boston

Judy Pfaff
Great Glasses, 1988
Mixed media
108 x 96 x 60
Courtesy of Holly Solomon Gallery, New York

Gerhard Richter
Neger II (Negro II), 1965
Oil on canvas
60 x 72
The Emily and Jerry Spiegel Collection,
Kings Point, New York

Gerhard Richter
Still, 1986
Oil on canvas
88 1/2 x 78 3/4
Collection of Raymond J. Learsy, Sharon, Connecticut

Andres Serrano
Circle of Blood, 1987
Cibachrome print
30 x 46
Courtesy of Stux Gallery, New York

Andres Serrano
Milk, Blood, 1986
Cibachrome print
30 x 40
Courtesy of Stux Gallery, New York

Haim Steinbach
no wires, no power cord, 1986
Mixed media construction
29 x 46 1/2 x 18 1/2
Collection of Elisabeth and Ealan Wingate, New York

Haim Steinbach
00:06 (2,4L), 1988
Mixed media construction
30 1/2 x 90 1/8 x 21
Courtesy of Jay Gorney Modern Art and
Sonnabend Gallery, New York

Philip Taaffe
Pharos, 1985
Silkscreen, collage and acrylic on paper
140 1/4 x 36
Collection of Donald and Mera Rubell, New York

Philip Taaffe
Strangulation with Necktie, 1986
Linoprint, collage and acrylic on paper
22 1/4 x 14 1/4
Collection of Peter Brams, Guttenberg, New Jersey

Philip Taaffe
Polygon, 1987
Silkscreen, collage and acrylic on canvas
55 x 70
Collection of Mr. and Mrs. Robert Sosnick,
Bloomfield Hills, Michigan

Rosemarie Trockel
Untitled (hammer and sickle flag), 1986
Knitted wool, stretched
59 x 51 1/4
Collection of Carol and Paul Meringoff,
New York

Rosemarie Trockel
Untitled, 1986
Knitted wool, stretched
57 x 65
Courtesy of Barbara Gladstone Gallery, New York

Wallace & Donohue
Star Search (The Light Painting), 1987
Latex on canvas with five track lights
72 x 60 x 29 1/2
Tony Shafrazi Gallery, New York

Wallace & Donohue
The Artist Disappears, 1987
Latex on canvas with wood
72 x 84 x 45
Collection of Michael Schwartz, New York

Terry Winters
Jew's Pitch, 1986
Oil on linen
81 x 166
Private Collection, New York

Terry Winters
Insecta, 1985
Oil on linen
102 x 69
Collection of Antonio Homem,
Courtesy of Sonnabend Gallery, New York

Christopher Wool
Untitled, 1987
Alykd on aluminum and steel
72 x 48
Collection of the artist,
Courtesy of Luhring Augustine Gallery, New York

Christopher Wool
Untitled, 1987
Alkyd on aluminum and steel
72 x 48
Collection of the artist,
Courtesy of Luhring Augustine Gallery, New York

Christopher Wool
Untitled, 1987
Alkyd on aluminum and steel
72 x 48
Collection of Marvin and Alvin Kosmin, New York
(not illustrated)

BIOGRAPHIES

RICHARD ARTSCHWAGER

Richard Artschwager was born in Washington, D.C., in 1923. He received a B.A. from Cornell University in 1948. In 1949, he studied with Amédée Ozenfant. He lives and works in New York.

His one-person exhibitions include those at Leo Castelli Gallery, New York (1965, 1967, 1972, 1973, 1975, 1978, 1979, 1981, 1985); Konrad Fischer, Düsseldorf (1968); Galerie Ricke, Cologne (1969, 1972); Museum of Contemporary Art, Chicago (1973); Galerie Sonnabend, Geneva (1974, 1975); Clocktower, New York (1978); Albright-Knox Art Gallery, Buffalo (1979, traveled to the Institute of Contemporary Art, Philadelphia; La Jolla Museum of Contemporary Art, La Jolla, California; Contemporary Arts Museum, Houston); Museum of Art, Rhode Island School of Design, Providence, Rhode Island (1980); Stedelijk Van Abbe Museum, Eindhoven, The Netherlands (1985); Whitney Museum of American Art, New York (1988).

His group exhibitions include *Plastics Show*, Albright-Knox Art Gallery, Buffalo (1964); *The Photographic Image*, Solomon R. Guggenheim Museum, New York (1966); *Primary Structures*, The Jewish Museum, New York (1966); *Contemporary American Sculpture, Section I*, Whitney Museum of American Art, New York (1966); *Pop Art*, Hayward Gallery, London (1969); *Information*, The Museum of Modern Art, New York (1970); *American Pop Art*, Whitney Museum of American Art, New York (1974); *Improbable Furniture*, Institute of Contemporary Art, Philadelphia (1977); *A View of a Decade*, Museum of Contemporary Art, Chicago (1977); *American Painting of the 1970s*, Albright-Knox Art Gallery, Buffalo (1978-1979); *Hidden Desires*, Neuberger Museum, State University of New York at Purchase, Purchase (1980); *XXXIX Biennale di Venezia*, Venice (1980); *Drawings: The Pluralist Decade*, Institute of Contemporary Art, Philadelphia (1980); *Postminimalism*, The Aldrich Museum of Contemporary Art, Ridgefield, Connecticut (1982); *Documenta 7*, Kassel, West Germany (1982); *Furniture, Furnishing: Subject and Object*, Museum of Art, Rhode Island School of Design, Providence (1984); *Definitive Statements: American Art 1964-66*, David Winton Bell Gallery, Brown University, Providence, Rhode Island (1986); *The Painter-Sculptor in the Twentieth Century*, Whitechapel Art Gallery, London (1986); *Biennial Exhibition*, Whitney Museum of American Art, New York (1987); *Made in the U.S.A.: An Americanization in Modern Art, The '50s and '60s*, University Art Museum, Berkeley, California (1987).

SELECT BIBLIOGRAPHY
Armstrong, Richard. *Artschwager, Richard*. Exhibition catalogue. New York: Whitney Museum of American Art and W.W. Norton & Company, 1988. Contains a select bibliography through 1988.

ROSS BLECKNER

Ross Bleckner was born in New York City in 1949. He received a B.A. in 1971 from New York University, New York, and a M.F.A. from the California Institute of the Arts, Valencia, California in 1973. He lives and works in New York.

His one-person exhibitions include those at Mary Boone Gallery, New York (1980, 1981, 1983, 1986, 1988); Patrick Verelist, Antwerp, Belgium (1982); Portico Row Gallery, Philadelphia (1982); Gallery Nature Morte, New York (1984); Boston Museum School, Boston (1985); Mario Diacono Gallery, Boston (1986); Margo Leavin Gallery, Los Angeles (1987); Waddington Gallery, London (1988); San Francisco Museum of Modern Art, San Francisco (1988).

His group exhibitions include the *Biennial Exhibition*, Whitney Museum of American Art, New York (1975, 1987); *Contemporary Reflections*, The Aldrich Museum of Contemporary Art, Ridgefield, Connecticut (1975); *New Work/New York*, Fine Arts Gallery, California State University, Los Angeles (1976); *New Painting/New York*, Hayward Gallery, London (1979); *Mary Boone and Her Artists*, Seibu Gallery, Tokyo (1983); *The Meditative Surface*, The Renaissance Society at the University of Chicago, Chicago (1984); *Vernacular Abstraction*, Wacoal Art Center, Tokyo (1985); *Endgame*, Institute of Contemporary Art, Boston (1986); *Post-Abstract Abstraction*, The Aldrich Museum of Contemporary Art, Ridgefield, Connecticut (1987); *CalArts: Skeptical Belief(s)*, The Renaissance Society at the University of Chicago, Chicago (1987, traveled to the Newport Harbor Art Museum, Newport Beach, California); *Seventh Biennale of Sydney*, Sydney (1988); *American Art of the Late '80s: The Binational*, Museum of Fine Arts, Boston, and the Institute of Contemporary Art, Boston (1988, traveled to Kunsthalle Düsseldorf, Kunstsammlung Nordrhein-Westfalen, Kunstverein für die Rheinlande und Westfalen, Düsseldorf, 1989); *Carnegie International*, The Carnegie Museum of Art, Pittsburgh (1988-1989).

SELECT BIBLIOGRAPHY
Cameron, Dan. "On Ross Bleckner's `Atmosphere' Paintings." *Arts Magazine* 61 (February 1987): 30-33.
Drake, Peter. "Ross Bleckner." *Flash Art* 129 (Summer 1986): 66-67.
Halley, Peter. "Ross Bleckner: Painting at the End of History." *Arts Magazine* 56 (May 1982): 132-33.
Klein, Mason. "Past and Perpetuity in the Recent Paintings of Ross Bleckner." *Arts Magazine* 61 (October 1986): 74-76.
Liebmann, Lisa. "Ross Bleckner's Mood Indigo." *ARTnews* 87 (May 1988): 128-33.
Melville, Stephen. "Dark Rooms: Allegory and History in the Paintings of Ross Bleckner." *Arts Magazine* 61 (April 1987): 56-58.
Pincus-Witten, Robert. "Defenestrations: Robert Longo and Ross Bleckner." *Arts Magazine* 57 (November 1982): 94-95.
Smith, Roberta. Exhibition review of Ross Bleckner. *Art in America* 69 (January 1981): 124-25.
Steir, Pat. "Where the Birds Fly, What the Lines Whisper." *Artforum* 25 (May 1987): 107-11.
Wei, Lilly. "Talking Abstract." *Art in America* 75 (July 1987): 80-97.
_____. "Ross Bleckner's Architecture of the Sky." *Arts Magazine* 63 (September 1988): 41-43.

JOHN CHAMBERLAIN

John Chamberlain was born in Rochester, Indiana, in 1927. He attended the School of The Art Institute of Chicago in 1951-1952 and Black Mountain College in 1955-1956. He lives and works in Sarasota, Florida, and on his boat *Clytie*.

His one-person exhibitions include those at Wells Street Gallery, Chicago (1957); Davida Gallery, New York (1958); Martha Jackson Gallery, New York (1960); Leo

Castelli Gallery, New York (1962, 1964, 1965, 1973, 1976, 1982); Galerie Ileana Sonnabend, Paris (1964); Dwan Gallery, Los Angeles (1966); The Cleveland Museum of Art, Cleveland (1967); Galerie Heiner Friedrich, Munich (1967); Galerie Rudolf Zwirner, Cologne (1967, 1984); Solomon R. Guggenheim Museum, New York (1971); Contemporary Arts Museum, Houston (1975, traveled to Missouri Botanical Gardens, St. Louis; Minneapolis Institute of Arts, Minneapolis); Margo Leavin Gallery, Los Angeles (1977, 1985); Mayor Gallery, London (1977); Galerie Heiner Friedrich, Cologne (1977-1978, 1979); Kunsthalle Bern, Bern (1977-1978); Stedelijk Van Abbe Museum, Eindhoven, The Netherlands (1980); Dia Art Foundation, New York (1982); The John and Mable Ringling Museum of Art, Sarasota, Florida (1983); The Butler Institute of American Art, Youngstown, Ohio (1983); Marian Goodman Gallery, New York (1983); The Art Museum of the Pecos, Marfa, Texas, and Dia Art Foundation, Marfa, Texas (1983); Palacio de Cristal, Parque del Retiro, Madrid (1984); Xavier Fourcade Gallery, New York (1984); Pace Gallery, New York (1989).

His group exhibitions include *Recent Sculpture USA*, The Museum of Modern Art, New York (1959); *Annual Exhibition*, Whitney Museum of American Art, New York (1960, 1962, 1964, 1966, 1970, 1973); *VI São Paolo Bienal*, São Paolo (1961); *The Art of Assemblage*, The Museum of Modern Art, New York (1961); *The Pittsburgh International Exhibition*, Museum of Art, Carnegie Institute, Pittsburgh (1961, 1967); *Six Sculptures*, Dwan Gallery, Los Angeles (1961); *Sixty-fifth Annual American Exhibition*, The Art Institute of Chicago, Chicago (1962); *Mixed Media and Pop Art*, Albright-Knox Art Gallery, Buffalo (1963); *XXXIV Biennale di Venezia*, Venice (1964); *Recent American Sculpture*, The Jewish Museum, New York (1964); *Modern Sculpture USA*, The Museum of Modern Art, New York (1965); *Art of the United States: 1670-1966*, Whitney Museum of American Art, New York (1966); *American Sculpture of the Sixties*, Los Angeles County Museum of Art, Los Angeles (1967); *Contemporary American Sculpture*, Whitney Museum of American Art, New York (1969); *Painting and Sculpture Today*, Indianapolis Museum of Art, Indianapolis (1969, 1970, 1972); *New York Painting and Sculpture: 1940-1970*, The Metropolitan Museum of Art, New York (1969); *Film-Video-Photography-Projektion*, Louisiana Museum, Humlebaek, Denmark (1972); *American Art Since 1945*, Philadelphia Museum of Art, Philadelphia (1972); *American Art 1948-1973*, Seattle Art Museum, Seattle (1973); *Video Tapes by Gallery Artists*, Leo Castelli Gallery, New York (1973); *Sculpture, American Directions, 1945-1975*, National Collection of Fine Arts, Smithsonian Institution, Washington, D.C. (1975); *Two Hundred Years of American Sculpture*, Whitney Museum of American Art, New York (1976); *Faszination des Objekts*, Museum moderner Kunst, Vienna (1980); *Reliefs/Formprobleme zwischen Malerei und Skulptur in 20. Jahrhundert*, Kunsthaus Zürich, Zürich (1980); *Westkunst*, Museum der Stadt Köln, Cologne (1981); *Documenta 7*, Kassel, West Germany (1981); *Borofsky, Chamberlain, Dahn, Knoebel*, Städtische Kunsthalle Düsseldorf, Düsseldorf (1983); *American Sculpture*, Seattle Art Museum, Seattle (1984); *Automobile and Culture*, The Museum of Contemporary Art, Los Angeles (1984); *Transformation in Sculpture: Four Decades of American and European Art*, Solomon R. Guggenheim Museum, New York (1985).

SELECT BIBLIOGRAPHY

Sylvester, Julie. *John Chamberlain: A Catalogue Raisonné of the Sculpture, 1954-1985*. New York: Hudson Hills Press, 1986. This monograph contains a complete listing of exhibitions and an extensive bibliography through 1986.

SARAH CHARLESWORTH

Sarah Charlesworth was born in East Orange, New Jersey, in 1947. She received a B.A. from Barnard College in 1969. She lives and works in New York.

Her one-person shows include those at the Galeries Eric Fabre, Paris (1978); Centre d'Art Contemporain, Geneva (1978); Galleria Pio Monti, Rome (1978); C Space, New York (1978); New 57 Gallery, Edinburgh (1979); Tony Shafrazi Gallery, New York (1980); Micheline Scwajcer, Antwerp (1981); Larry Gagosian, New York (1982); Clocktower, New York (1984); International with Monument, New York (1985, 1986, 1987); California Museum of Photography, Riverside, California (1985); Tyler Galleries, Tyler School of Art, Temple University, Elkins Park, Pennsylvania (1987); Margo Leavin Gallery, Los Angeles (1987); Hufkens-Noirhomme, Brussels (1988).

Her group exhibitions include untitled shows at the PMJ Self Gallery, London (1976), Art Net, London (1977), and Gallery 76, Toronto (1978); *Artemesia*, Galerie Yvon Lambert, Paris (1979); *The Altered Photograph*, P.S. 1, Long Island City, New York (1979); *The Times Square Show*, Times Square, New York (1980); *New York, New Wave*, P.S. 1, Long Island City, New York (1981); *Photo*, Metro Pictures, New York (1981); *Resource Material: Appropriation in Current Photography*, Proctor Art Center, Bard College, Annandale-On-Hudson, New York (1982); *Art and the Media, A Fatal Attraction*, The Renaissance Society at the University of Chicago, Chicago (1982); *Art and Social Change*, Allen Memorial Art Museum, Oberlin, Ohio (1983); *The New Capital*, White Columns, New York (1984); *Still Life with Transaction*, Galerie Jurka, Amsterdam (1984); *The Art of Memory, The Loss of History*, The New Museum of Contemporary Art, New York (1985); *Infotainment*, Texas Gallery, Houston (1985, traveled to Rhona Hoffman Gallery, Chicago; Vanguard Gallery, Philadelphia; The Aspen Art Museum, Aspen, Colorado); *Biennial Exhibition*, Whitney Museum of American Art, New York (1985); *Art and Its Double*, Fondació Caixa de Pensions, Barcelona and Madrid (1986); *XLII Biennale di Venezia*, Venice (1986); *As Found*, Institute of Contemporary Art, Boston (1986); *The Big Picture*, The Queens Museum, Flushing, New York (1986); *This Is Not a Photograph: Twenty Years of Large-Scale Photography, 1966-1986*, The John and Mable Ringling Museum of Art, Sarasota, Florida (1987); *The Discursive Field of Recent Photography*, Artculture Resource Center, Toronto (1988); *Media Post Media*, Scott Hanson Gallery, New York (1988); *Art at the End of the Social*, Rooseum, Malmö, Sweden (1988).

SELECT BIBLIOGRAPHY

California Museum of Photography, San Francisco. *California Museum of Photography Bulletin* 3 (Winter 1985). Exhibition catalogue.

Cameron, Dan. *Art and Its Double: Recent Developments in New York Art*. Exhibition catalogue. Barcelona: Fondació Caixa de Pensions, 1986.

Clarkson, David. "Interview with Sarah Charlesworth." *Parachute* 49 (December 1987): 12-15.

Frank, Elizabeth. Exhibition review of Sarah Charlesworth. *Art in America* 68 (April 1980): 131.

Gilbert-Rolfe, Jeremy. "Where Do Pictures Come From? Sarah Charlesworth and the Development of the Sign." *Arts Magazine* 62 (December 1987): 58-60.

Hagan, Chuck. Exhibition review of Sarah Charlesworth. *Artforum* 21 (December 1982): 80-81.

Kohn, Michael. Exhibition review of Sarah Charlesworth. *Flash Art* 122 (April/May 1985): 40-41.

Linker, Kate. Exhibition review of Sarah Charlesworth. *Artforum* 23 (Summer 1985): 105-106.

Owens, Craig. Exhibition review of Sarah Charlesworth. *Art in America* 70 (May 1982): 141.

Saltz, Jerry. "The Implacable Distance: Sarah Charlesworth's *Unidentified Woman, Hotel Corona, Madrid (1979-1985)."* *Arts Magazine* 62 (March 1988): 24-25.
Warren, Ron. Exhibition review of Sarah Charlesworth. *Arts Magazine* 59 (May 1985): 44.

TONY CRAGG

Tony Cragg was born in Liverpool, England, in 1949. He attended the Gloucestershire College of Art and Design from 1969 to 1970, the Wimbledon School of Art from 1970 to 1973, and the Royal College of Art from 1973 to 1977, receiving a M.A. degree. He has lived and worked in Wuppertal, West Germany, since 1977 and has taught at the Düsseldorf Kunstakademie since 1979.

His one-person exhibitions include those at Lisson Gallery, London (1979); Konrad Fischer, Düsseldorf (1980, 1982, 1986); Chantal Crousel, Paris (1980, 1982, 1984); Galleria Lucio Amelio, Naples (1980, 1983); Musée d'Art et d'Industrie, St. Etienne, France (1981); Whitechapel Art Gallery, London (1981); Von der Heydt-Museum, Wuppertal, West Germany (1981); Nouveau Musée, Lyon, France (1981, 1982); Rijksmuseum Kröller-Müller, Otterlo, The Netherlands (1982); Marian Goodman Gallery, New York (1982, 1983, 1984, 1986, 1988); Kunsthalle Bern, Bern (1983); Louisiana Museum, Humlebaek, Denmark (1984); Kölnischer Kunstverein, Cologne (1984); Kunsthalle Waghaus, Winterthur, Switzerland (1985); Staatsgalerie moderner Kunst, Munich (1985); Palais des Beaux-Arts, Brussels (1985, traveled to ARC, Musée d'Art Moderne de la Ville de Paris, Paris); Hannover Gesellschaft, Hannover, West Germany (1986); The Brooklyn Museum of Art, Brooklyn (1986); Hayward Gallery, London (1986).

His group shows include *Europa Kunst der 80er Jahre,* Stuttgart (1979); *XVI Triennale di Milano,* Milan (1980); *XXXIX Biennale di Venezia,* Venice (1980); *Kunst in Europa na '68,* Museum van Hedendaagse Kunst, Gent, Belgium (1980); *British Sculpture in the 20th Century,* Whitechapel Art Gallery, London (1981); *Documenta 7,* Kassel, West Germany (1982); *Leçons des Choses,* Kunsthalle Bern, Bern (1982); *British Sculpture Now,* Kunsthalle Luzern, Lucerne (1982); *Kunst wird Material,* Nationalgalerie, West Berlin (1982); *New Art,* Tate Gallery, London (1983); *An International Survey of Recent Painting and Sculpture,* The Museum of Modern Art, New York (1984); *Hayward Annual 1985,* Hayward Gallery, London (1985); *Beuys zu Ehren,* Städtische Galerie im Lenbachhaus, Munich (1986); *Spuren, Skulpturen und Monumente ihrer präzisen Reise,* Kunsthaus Zürich, Zürich (1986).

SELECT BIBLIOGRAPHY
Cooke, Lynne. *Tony Cragg.* Exhibition catalogue. Hayward Gallery, London. London: Arts Council of Great Britain, 1987.
Davvetas, Demosthene, and Annelie Pohlen. *Tony Cragg.* Exhibition catalogue. Brussels: Société des Expositions du Palais des Beaux-Arts de Bruxelles, Paris; ARC, Musée d'Art Moderne de la Ville de Paris, 1985. Contains a select bibliography for all publications prior to 1985.

CARROLL DUNHAM

Carroll Dunham was born in New Haven, Connecticut, in 1949. He attended Trinity College, Hartford, Connecticut. He lives and works in New York.

His one-person exhibitions include those at Artists Space, New York (1981); Daniel Weinberg Gallery, Los Angeles (1985, 1987); Baskerville + Watson Gallery, New York (1985); Barbara Krakow Gallery, Boston (1986); Jay Gorney Modern Art, New York (1987); Tyler Galleries, Tyler School of Art, Temple University, Elkins Park, Pennsylvania (1988); Galerie Fred Jann, Munich (1988).

His group exhibitions include *Lineup,* Drawing Center, New York (1978); *Young American Artists,* Schema Gallery, Florence (1978); *Watercolors,* P.S. 1, Long Island City, New York (1980); *Four Painters,* Massachusetts Institute of Technology, Cambridge (1981); *Carroll Dunham and Terry Winters,* Galerie Jean Bernier, Athens (1983); *Nine Painters,* Hallwalls, Buffalo (1983); *Tradition, Transition, New Vision,* Addison Gallery of American Art, Phillips Academy, Andover, Massachusetts (1983); *New Biomorphism and Automatism,* Hamilton Gallery, New York (1983); *New York Now—Works on Paper,* Nordjyllands Kunstmuseum, Aalborg, Denmark (1984); *Painting as Landscape,* The Parrish Art Museum, Southampton, New York (1985); *Currents,* Institute of Contemporary Art, Boston (1985); *Biennial Exhibition,* Whitney Museum of American Art, New York (1985); *Private and Public: American Prints Today,* The Brooklyn Museum, Brooklyn (1986); *Paravision,* Margo Leavin Gallery, Los Angeles (1986); *NY Art Now: The Saatchi Collection,* The Saatchi Collection, London (1988); *Vital Signs: Organic Abstraction from the Permanent Collection,* Whitney Museum of American Art, New York (1988); *Altered States,* Kent Fine Art, New York (1988).

SELECT BIBLIOGRAPHY
Cameron, Dan. "Neo-Surrealism: Having It Both Ways." *Arts Magazine* 59 (November 1984): 68-73.
Gould, Claudia. *Nine Painters.* Exhibition catalogue. Buffalo: Hallwalls, 1983.
Halbreich, Kathy. *Four Painters.* Exhibition catalogue. Cambridge: MIT, Committee on the Visual Arts, 1981.
Lovelace, Carey. Exhibition review of Carroll Dunham. *ARTnews* 85 (October 1986): 138.
Saltz, Jerry. "Carroll Dunham's *Untitled* (1987)." *Arts Magazine* 62 (January 1988): 58-59.
Schwabsky, Barry. Exhibition review of Carroll Dunham. *Flash Art* 131 (December/January 1986): 90.

DIANA FORMISANO

Diana Formisano was born in Newburgh, New York, in 1960. She attended the Art Institute of Pittsburgh, the State University of New York at Buffalo, Empire State College in New York, and the State University of New York at Plattsburgh, from which she received her B.A.

She had a one-person exhibition at Postmasters Gallery, New York, in 1987. Her group exhibitions include *New Art with Time and Electronics,* International with Monument, New York (1984); *Neue Kunst—Zeit und Electronik,* Off Galerie, West Berlin (1984); *TV Pictures,* The New Museum of Contemporary Art, New York (1985); *Everything But . . .,* The Kitchen, New York (1986); *Altered States,* Procter Art Center, Bard College, Annandale-on-Hudson, New York (1986); *Spiritual America,* CEPA Gallery, Buffalo (1986); *(C)Overt, The Logic of Display,* P.S. 1, Long Island City, New York (1988); *Photography on the Edge,* The Patrick and Beatrice Haggerty Museum of Art, Marquette University, Milwaukee (1988).

SELECT BIBLIOGRAPHY
Cameron, Dan. "Post-Feminism." *Flash Art* 132 (February/March 1987): 80-83.
———. "Opening Salvos: Part Two." *Arts Magazine* 62 (February 1988): 18-22.
Smith, Roberta. "Media Post Media, A Show of Nineteen Women." *New York Times,* January 15, 1988.

ROBERT GOBER

Robert Gober was born in Wallingford, Connecticut, in 1954. He received a B.A. from Middlebury College in 1976 and attended the Tyler School of Art in Rome in 1973-1974. He lives and works in New York.

His one-person exhibitions include those at Paula Cooper Gallery, New York (1984, 1985, 1987); Daniel Weinberg Gallery, Los Angeles (1985, 1986); Galerie Jean Bernier, Athens (1987); Tyler Galleries, Tyler School of Art, Temple University, Elkins Park, Pennsylvania (1988); The Art Institute of Chicago, Chicago (1988).

His group exhibitions include *Three Look into American Home Life*, Ian Berkstedt Gallery, New York (1981); *New York Work*, Studio 10, Chur, Switzerland (1983); *Scapes*, University Art Museum, University of California, Santa Barbara (1985, traveled to the University of Hawaii at Manoa, Honolulu, 1986); *Robert Gober, Jeff Koons, Peter Nadin, Meyer Vaisman*, Jay Gorney Modern Art, New York (1986); *Drawing*, Knight Gallery, Spirit Square Center for the Arts, Charlotte, North Carolina (1986); *Objects from the Modern World*, Daniel Weinberg Gallery, Los Angeles (1986); *New Sculpture: Robert Gober, Jeff Koons, Haim Steinbach*, The Renaissance Society at the University of Chicago, Chicago (1986); *Art and Its Double*, Fondació Caixa de Pensions, Barcelona and Madrid (1986); *Avant-Garde in the Eighties*, Los Angeles County Museum of Art, Los Angeles (1987); *NY Art Now: The Saatchi Collection*, The Saatchi Collection, London (1987); *LXIII Biennale di Venezia*, Venice (1988); *Furniture as Art*, Museum Boymans-van Beuningen, Rotterdam (1988).

SELECT BIBLIOGRAPHY

Cameron, Dan. *NY Art Now: The Saatchi Collection*. Exhibition Catalogue. N.p.: Giancarlo Politi Editore, n.d.

Collins, Tricia, and Richard Milazzo. "Robert Gober: The Subliminal Function of Sinks." *Kunstforum* 84 (June/August 1986): 320-22.

Colombo, Paolo. *Robert Gober*. Exhibition catalogue. Elkins Park, Pennsylvania: Tyler Galleries, Tyler School of Art, 1988.

Fox, Howard. *Avant-Garde in the Eighties*. Exhibition catalogue. Los Angeles: Los Angeles County Museum of Art, 1987.

Garrels, Gary. *New Sculpture*. Exhibition catalogue. Chicago: The Renaissance Society at the University of Chicago, 1986.

Joselit, David. "Investigating the Ordinary." *Art in America* 76 (May 1988): 148-54.

Mahoney, Robert. "Real Inventions/Invented Functions." *Arts Magazine* 62 (May 1988): 102.

Marincola, Paula. Exhibition review of Robert Gober. *Artforum* 26 (May 1988): 153.

Museum Boymans-van Beuningen, Rotterdam. *Furniture as Art*. Exhibition catalogue. Rotterdam: Museum Boymans-van Beuningen, 1988.

Plous, Phyllis. *Scapes*. Exhibition catalogue. Santa Barbara: University Art Museum, University of California, Santa Barbara, 1985.

Princenthal, Nancy. Exhibition review of Robert Gober. *Art in America* 75 (December 1987): 153-54.

Rinder, Larry. Exhibition review of Kevin Larmon and Robert Gober. *Flash Art* 128 (May/June 1986): 56-57.

PETER HALLEY

Peter Halley was born in New York City in 1953. He received his B.A. from Yale University in 1975 and a M.F.A. from the University of New Orleans in 1978. He lives and works in New York.

His one-person exhibitions include those at the Contemporary Arts Center, New Orleans (1978); School of Art and Architecture, University of Southwestern Louisiana, Lafayette (1979); P.S. 122 Gallery, New York (1980); Beulah Land, New York (1984); International with Monument, New York (1985, 1986); Galerie Daniel Templon, Paris (1986); Margo Leavin Gallery, Los Angeles (1987); Sonnabend Gallery, New York (1987); Rhona Hoffman Gallery, Chicago (1988); Galerie Bruno Bischofberger, Zürich (1988); Arthur Roger Gallery, New Orleans (1988); Galerie Jablonka, Cologne (1988).

His group exhibitions include shows at Newspace Gallery, New Orleans (1978), the American Academy and Institute of Arts and Letters, New York (1979), and the Contemporary Arts Center, New Orleans (1980); *Dangerous Works*, Parsons School of Design, New York (1982); *Tradition, Transition, New Vision*, Addison Gallery of American Art, Phillips Academy, Andover, Massachusetts (1983); *The New Capital*, White Columns, New York (1984); *Re-Place-Ment*, Hallwalls, Buffalo (1984); *Currents*, Institute of Contemporary Art, Boston (1985); *Infotainment*, Texas Gallery, Houston (1985, traveled to Rhona Hoffman Gallery, Chicago; Vanguard Gallery, Philadelphia; The Aspen Art Museum, Aspen, Colorado); *XVIII São Paolo Bienal*, São Paulo (1985); *Art and Its Double*, Fondació Caixa de Pensions, Barcelona and Madrid (1986); *End Game*, Institute of Contemporary Art, Boston (1986); *Painting and Sculpture Today*, Indianapolis Museum of Art, Indianapolis, Indiana (1986); *New New York*, Cleveland Center for Contemporary Art, Cleveland (1986); *Spiritual America*, CEPA Gallery, Buffalo (1986); *Currents 12: Simulations, New American Conceptualism*, Milwaukee Art Museum, Milwaukee (1987); *Anti-Baudrillard*, White Columns, New York (1987); *Documenta 8*, Kassel, West Germany (1987); *Avant-Garde in the Eighties*, Los Angeles County Museum of Art, Los Angeles (1987); *Extreme Order*, Galleria Lia Rumma, Naples (1987); *NY Art Now: The Saatchi Collection*, The Saatchi Collection, London (1987); *Similia/Dissimilia*, Städtische Kunsthalle Düsseldorf, Düsseldorf (1987, traveled to Wallach Art Gallery, Columbia University; Leo Castelli Gallery; and Sonnabend Gallery, New York); *Terrae Motus*, Grand Palais, Paris (1987); *Cultural Geometry*, The Deste Foundation for Contemporary Art, Deka House of Cyprus, Athens (1988); *Art at the End of the Social*, Rooseum, Malmö, Sweden (1988); *La Couleur Seule*, Musée Saint Pierre, Lyon (1988).

SELECT BIBLIOGRAPHY

Bois, Yve-Alain, Thomas Crow, Hal Foster, David Joselit, Bob Riley, and Elisabeth Sussman. *Endgame: Reference and Simulation in Recent Painting and Sculpture*. Exhibition catalogue. Cambridge, Massachusetts: MIT Press, 1986.

Cameron, Dan. *Art and Its Double: Recent Developments in New York Art*. Exhibition catalogue. Barcelona: Fondació Caixa de Pensions, 1986.

_____. "In the Path of Peter Halley." *Arts Magazine* 62 (December 1987): 70-73.

Cone, Michele. Exhibition review of Peter Halley. *Flash Art* 126 (February/March 1986): 49-50.

Cotter, Holland. Exhibition review of Peter Halley. *Flash Art* 129 (Summer 1986): 68-69.

Foster, Hal. "Signs Taken for Wonders." *Art in America* 74 (June 1986): 81-91, 139.

Halley, Peter. *Peter Halley, Collected Essays, 1981-87*. Zürich: Bruno Bischofberger, 1988.

Hart, Claudia. "Intuitive Sensitivity: An Interview with Peter Halley and Meyer Vaisman." *Artscribe* 66 (November/December 1987): 36–39.

Jones, Ronald. "Six Artists at the End of the Line: Gretchen Bender, Ashley Bickerton, Peter Halley, Louise Lawler, Allan McCollum, and Peter Nagy." *Arts Magazine* 60 (May 1986): 49-51.

_____. Exhibition review of Peter Halley. *Artscribe* 70 (Summer 1988): 50.

Kuspit, Donald. Exhibition review of Peter Halley. *Artforum* 26 (January 1988): 112-13.

Nagy, Peter, and George W.S. Trow. *Infotainment*. Exhibition catalogue. New York: J. Berg Press, 1985.

Madoff, Steven Henry. "Vestiges and Ruins: Ethics and Geometric Art in the Twentieth Century." *Arts Magazine* 61 (December 1986): 32-40.

McCormick, Carlo. "Poptometry." *Artforum* 24 (November 1985): 87-91.

Siegel, Jeanne. "Geometry Desurfacing." *Arts Magazine* 60 (March 1986): 26-32.

Wei, Lilly. "Talking Abstraction." *Art in America* 75 (December 1987): 112-30.

RONALD JONES

Ronald Jones was born in Falls Church, Virginia, in 1952. He received a B.F.A. in 1974 from Huntington College in Montgomery, Alabama, a M.F.A. in 1976 from the University of South Carolina in Columbia, South Carolina, and a Ph.D. in art history in 1981 from Ohio University in Athens, Ohio.

His one-person exhibitions include those at Centro Documentazione Arte, Rome (1983); Contemporary Arts Center, New Orleans (1985); High Museum of Art, Atlanta (1986); Heath Gallery, Atlanta (1986); Gallery One, Spirit Square Center for the Arts, Charlotte, North Carolina (1986); Metro Pictures, New York (1987, 1988); Julian Pretto, New York (1987); Isabella Kacprzak, Stuttgart (1988).

His group exhibitions include *Terminal New York, Preparing for War*, Brooklyn Army Terminal, Brooklyn (1983); *The Political Show*, Nexus Contemporary Art Center, Atlanta (1984); *Photostatic Images*, Southeastern Center for Contemporary Art, Winston-Salem, North Carolina (1984); *The Written Word*, Southeastern Center for Contemporary Art, Winston-Salem, North Carolina (1986); *The New Poverty*, John Gibson Gallery, New York (1987); *Documenta 8*, Kassel, West Germany (1987); *Altered States*, Kent Fine Art, New York (1988); *Material Ethics* and *Stilltrauma*, Milford Gallery, New York (1988); *Skulpturen Republik*, Kunstraum Wien im Messepalast, Vienna (1988).

SELECT BIBLIOGRAPHY

Bankowsky, Jack. Exhibition review of Ronald Jones. *Flash Art* 135 (Summer 1987): 107-108.

Craven, Richard. *Photostatic Images*. Exhibition catalogue. Winston-Salem, North Carolina: Southeastern Center for Contemporary Art, 1984.

Gablik, Suzi. *Has Modernism Failed?* New York: Thames and Hudson, 1984.

_____. "Confrontational Culture and the Myth of Change: An Interview with Ronald Jones." *New Art Examiner* 15 (April 1988): 31-32.

Heartney, Eleanor. Exhibition review of Ronald Jones. *Art in America* 76 (January 1988): 132-33.

Howett, John. *A Tribute to the Future*. Exhibition catalogue. Atlanta: High Museum of Art, 1987.

Kunstraum Wien im Messepalast, Vienna. *Skulpturen Republik*. Exhibition catalogue. Vienna: Kunstraum Wien im Messepalast, 1988.

McCoy, Pat. Exhibition review of Ronald Jones. *Artscribe* 67 (January/February 1988): 72-73.

ANNETTE LEMIEUX

Annette Lemieux was born in Norfolk, Virginia, in 1957. She received a B.F.A. in 1980 from Hartford Art School, University of Hartford, West Hartford, Connecticut. She lives and works in New York and Boston.

Her one-person exhibitions include Joseloff Gallery, Hartford Art School, University of Hartford, West Hartford, Connecticut (1980); Artists Space, New York (1984); Cash/Newhouse, New York (1986, 1987); Josh Baer Gallery, New York (1987); Daniel Weinberg Gallery, Los Angeles (1987); Lisson Gallery, London (1988); Wadsworth Atheneum, Hartford, Connecticut (1988).

Her group exhibitions include *Contemporary Shields*

Show, Gallery des Refuse, New York (1982); *Connecticut 7 + 7 + 7*, Wadsworth Atheneum, Hartford, Connecticut (1983); *Artist Call*, Metro Pictures, New York (1984); *Symbols Cliche*, A & M Gallery, New York (1984); *Past and Future Perfect*, Hallwalls, Buffalo (1985); *A Brave New World, A New Generation*, Charlottenborg Exhibition Hall, Copenhagen (1985); *Time After Time*, Diane Brown Gallery, New York (1986); *Altered States*, Proctor Art Center, Bard College, Annandale-on-Hudson, New York (1986); *Spiritual America*, CEPA, Buffalo (1986); *Ultrasurd*, S.L. Simpson, Toronto (1986); *Modern Sleep*, American Fine Arts, New York (1986); *The Antique Future*, Massimo Audiello Gallery, New York (1987); *Currents*, Institute of Contemporary Art, Boston (1987); *Extreme Order*, Galleria Lia Rumma, Naples (1987); *Fake*, The New Museum of Contemporary Art, New York (1987); *Biennial Exhibition*, Whitney Museum of American Art, New York (1987); *Romance*, Knight Gallery, Spirit Square Center for the Arts, Charlotte, North Carolina (1987); *Currents 12: Simulations, New American Conceptualism*, Milwaukee Art Museum, Milwaukee (1987); *The Beauty of Circumstance*, Josh Baer Gallery, New York (1987); *Cultural Geometry*, The Deste Foundation for Contemporary Art, Deka House of Cyprus, Athens (1988); *Media Post Media*, Scott Hanson Gallery, New York (1988); *Photography on the Edge*, The Patrick and Beatrice Haggerty Museum of Art, Marquette University, Milwaukee (1988); *Altered States*, Kent Fine Art, New York (1988); *Art at the End of the Social*, Rooseum, Malmö, Sweden (1988).

SELECT BIBLIOGRAPHY

Brooks, Rosetta. "Remembrance of Objects Past." *Artforum* 25 (December 1986): 68-69.

_____. "Space Fictions." *Flash Art* 131 (December 1986): 78-80.

Cameron, Dan. "Post-Feminism." *Flash Art* 132 (February/March 1987): 80-83.

Heartney, Eleanor. "Simulationism, The Hot New Cool Art." *ARTnews* 86 (January 1987): 130-37.

Indiana, Gary. Exhibition review of Annette Lemieux. *Art in America* 74 (July 1986): 119.

Linker, Kate. "Eluding Definition." *Artforum* 23 (December 1984): 61-67.

Pincus-Witten, Robert. "Entries: Annette Lemieux, An Obsession with Stylistics: Painter's Guilt." *Arts Magazine* 63 (September 1988): 32-37.

Siegel, Jeanne. "It's a Wonderful Life, or is It?" *Arts Magazine* 61 (January 1987): 78-81.

Smith, Roberta. "Art: Annette Lemieux in Two Mixed Media Shows." *New York Times*, April 17, 1987.

ELIZABETH MURRAY

Elizabeth Murray was born in Chicago, Illinois, in 1940. She received a B.F.A. in 1962 from The Art Institute of Chicago and a M.F.A. in 1964 from Mills College, Oakland, California. She lives and works in New York.

Her one-person exhibitions include those at Jared Sable Gallery, Toronto (1975); Paula Cooper Gallery, New York (1976, 1978, 1981, 1983, 1984, 1987); University Gallery of Fine Art, Ohio State University, Columbus, Ohio (1978); Galerie Mukai, Tokyo (1980); Susanne Hilberry Gallery, Birmingham, Michigan (1980); Hillyer Gallery, Smith College, Northampton, Massachusetts (1982); Daniel Weinberg Gallery, Venice, California (1982); Portland Center for the Visual Arts, Portland (1983); Knight Gallery, Spirit Square Center for the Arts, Charlotte, North Carolina (1984); Institute of Contemporary Art, Boston (1984); University Art Museum, The University of New Mexico, Albuquerque (1985); Carnegie-Mellon University Art Gallery, Pittsburgh (1986); Dallas Museum of Art, Dallas (1987, traveled to Albert and Vera List Visual Arts Center, Massachusetts Institute of Technology, Cam-

bridge; Museum of Fine Arts, Boston; The Museum of Contemporary Art, Los Angeles; Des Moines Art Center, Des Moines, Iowa; Walker Art Center, Minneapolis; Whitney Museum of American Art, New York).

Her group exhibitions include the *Annual* or *Biennial Exhibition*, Whitney Museum of American Art, New York (1972, 1973, 1977, 1979, 1981, 1985); *Approaching Painting, Part Three*, Hallwalls, Buffalo (1976); *A View of a Decade*, Museum of Contemporary Art, Chicago (1977); *Two Decades of Abstraction: New Abstraction*, University of South Florida Art Galleries, Tampa (1978); *Eight Abstract Painters*, Institute of Contemporary Art, Philadelphia (1978); *New Painting/New York*, Hayward Gallery, London (1979); *American Painting: The Eighties*, The Grey Art Gallery and Study Center, New York University, New York (1979); *Amerikanische Malerie 1930-1980*, Haus der Kunst, Munich (1981); *American Prints*, Milwaukee Art Museum, Milwaukee (1982); *Great Big Drawings*, Hayden Gallery, Massachusetts Institute of Technology, Cambridge, Massachusetts (1982); *Abstract Drawings*, Whitney Museum of American Art, New York (1982); *74th American Exhibition*, The Art Institute of Chicago, Chicago (1982); *Directions 1983*, Hirshhorn Museum and Sculpture Garden, Washington, D.C. (1983); *Language, Drama, Source and Vision*, The New Museum of Contemporary Art, New York (1983); *The American Artist As Printmaker*, The Brooklyn Museum, Brooklyn (1983); *Five Painters in New York*, Whitney Museum of American Art, New York (1984); *Painting and Sculpture Today 1984*, Indianapolis Museum of Art, Indianapolis, Indiana (1984); *An International Survey of Recent Painting and Sculpture*, The Museum of Modern Art, New York (1984); *Contemporary Perspectives 1984*, Center Gallery of Bucknell University, Lewisburg, Pennsylvania (1984); *A New Beginning 1968-1978*, The Hudson River Museum of Westchester, Yonkers, New York (1985); *Scapes*, University Art Museum, University of California, Santa Barbara (1985, traveled to the University of Hawaii Art Gallery, Honolulu); *Large Drawings*, The Museum of Modern Art, New York (1985); *Drawings*, Knight Gallery, Spirit Square Center for the Arts, Charlotte, North Carolina (1985); *An American Renaissance: Painting and Sculpture Since 1940*, Museum of Art, Fort Lauderdale, Florida (1986); *NYC: New Work*, Delaware Art Museum, Wilmington, Delaware (1986); *Individuals: A Selected History of Contemporary Art 1945-1986*, The Museum of Contemporary Art, Los Angeles (1986-87); *40th Biennial of Contemporary American Painting*, Corcoran Gallery of Art, Washington, D.C. (1987); *Comic Iconoclasm*, Institute of Contemporary Arts, London (1987).

SELECT BIBLIOGRAPHY
Galligan, Gregory. "Elizabeth Murray's New Paintings." *Arts Magazine* 62 (September 1987): 62-66.
Graze, Sue, Kathy Halbreich, Roberta Smith, and Clifford S. Ackley. *Elizabeth Murray: Paintings and Drawings*. Exhibition catalogue. New York: Harry N. Abrams, 1986. Contains a selected bibliography through 1986.
Johnson, Ken. "Elizabeth Murray's New Paintings." *Arts Magazine* 62 (September 1987): 67-69.
King, Elaine A., and Ann Sutherland Harris. *Elizabeth Murray: Drawings 1980-1986*. Exhibition catalogue. Pittsburgh: Carnegie-Mellon University Art Gallery, 1986.
Lewallen, Constance. *Elizabeth Murray: Matrix/Berkeley*. Exhibition catalogue. Berkeley: University Art Museum, University of California, 1987.
Schwabsky, Barry. Exhibition review of Elizabeth Murray. *Flash Art* 135 (Summer 1987): 107.
Tillim, Sidney. Exhibition review of Elizabeth Murray. *Art in America* 75 (October 1987): 177.

JUDY PFAFF

Judy Pfaff was born in London, England, in 1946. She received a B.F.A. in 1971 from Washington University in St. Louis and a M.F.A. in 1973 from Yale University. She lives in New York and has a studio in Brooklyn.

Her one-person exhibitions include those at Artists Space, New York (1978); Holly Solomon Gallery, New York (1980, 1983, 1986, 1988); The John and Mable Ringling Museum of Art, Sarasota, Florida (1981); Hallwalls, Buffalo (1982); Daniel Weinberg Gallery, Los Angeles (1984); Knight Gallery, Spirit Square Center for the Arts, Charlotte, North Carolina (1986); Susanne Hilberry Gallery, Detroit (1987); Carnegie-Mellon University Art Gallery, Pittsburgh (1988); The National Museum of Women in the Arts, Washington, D.C. (1988).

Her group exhibitions include the *Biennial Exhibition*, Whitney Museum of American Art, New York (1975, 1981, 1987); *Approaching Painting, Part II*, Hallwalls, Buffalo (1976); *10 Artists/Artists Space*, Neuberger Museum, State University of New York at Purchase, Purchase (1979); *Sculptural Perspectives*, University Art Museum, University of California, Santa Barbara (1979); *Extensions: Jennifer Bartlett, Lynda Benglis, Robert Longo, Judy Pfaff*, Contemporary Arts Museum, Houston (1980); *Directions 1981*, Hirshhorn Museum and Sculpture Garden, Washington, D.C. (1981); *Zeitgenossische Kunst seit 1939*, Kölnisches Stadtmuseum, Cologne (1981); *XL Biennale di Venezia*, Venice (1982); *A New Beginning*, The Hudson River Museum of Westchester, Yonkers, New York (1985).

SELECT BIBLIOGRAPHY
Armstrong, Richard. Exhibition review of Judy Pfaff. *Artforum* 21 (March 1983): 78-79.
Arnason, H. Harvard. *The History of Modern Art*. 3rd ed. New York: Harry N. Abrams, 1986.
Auping, Michael. "Judy Pfaff: Turning Landscape Inside Out." *Arts Magazine* 57 (September 1982): 74-76.
Carrie, Rickey. Exhibition review of Judy Pfaff. *Artforum* 19 (November 1980): 91-93.
Collings, Betty. Exhibition review of Judy Pfaff. *Arts Magazine* 55 (November 1980): 4.
Gardner, Paul. "Blissful Havoc." *ARTnews* 82 (Summer 1983): 68-74.
Gill, Susan. "Beyond the Perimeters: The Eccentric Humanism of Judy Pfaff." *Arts Magazine* 61 (October 1986): 77-79.
Karafel, Lorraine. Exhibition review of Judy Pfaff. *ARTnews* 85 (October 1986): 129-30.
Nochlin, Linda, and Helaine Posner. *Judy Pfaff*. Exhibition catalogue. New York: Holly Solomon Gallery; Washington, D.C.: National Museum of Women in the Arts, 1988. Contains a complete exhibition history.
Saunders, Wade. Exhibition review of Judy Pfaff. *Art in America* 68 (November 1980): 135.
_____. "Talking Objects: Interviews with Ten Younger Sculptors." *Art in America* 73 (November 1985): 131.
Shore, Michael. "How Does It Look, How Does It Sound?" *ARTnews* 79 (November 1980): 78-85.
Smith, Roberta. "Pfaff's Progress: Off the Wall and Back." *Judy Pfaff, Autonomous Objects*. Exhibition catalogue. Charlotte, North Carolina: Knight Gallery, Spirit Square Center for the Arts, 1986. Contains a select bibliography through 1986.
Yau, John. "Art on Location: The Arc of a Diver—Judy Pfaff." *Artforum* 24 (Summer 1986): 10-11.

GERHARD RICHTER

Gerhard Richter was born in Dresden in 1932. He studied at the Kunstakademie in Dresden from 1951 to 1956 and at the Staatliche Kunstakademie in Düsseldorf from 1961 to 1963. He has lived and worked in Cologne since 1983.

His one-person exhibitions include those at Galerie Heiner Friedrich, Munich (1964, 1967, 1970, 1974); Galerie René Block, West Berlin (1964, 1966, 1969, 1974); Galerie Bruno Bischofberger, Zürich (1966); Galerie Rudolf Zwirner, Cologne (1968); Palais des Beaux-Arts, Brussels (1970, 1976); Konrad Fischer, Düsseldorf (1970, 1972, 1975, 1983); Museum Folkwang, Essen, West Germany (1970, 1980); XXXV Biennale di Venezia, Venice (1972); Kunstmuseum Luzern, Lucerne (1972); Suermondt-Ludwig Museum, Aachen, West Germany (1972); Galerie Heiner Friedrich, Cologne (1972, 1974); Galleria Lucio Amelio, Naples (1972, 1983); Städtische Galerie im Lenbachhaus, Munich (1973); Reinhard Onnasch Gallery, New York (1973); Städtisches Museum Abteilberg Mönchengladbach, Mönchengladbach, West Germany (1974); Rolf Preisig, Basel (1975); Kunstverein Braunschweig, Braunschweig, West Germany (1975); Kunsthalle Bremen, Bremen, West Germany (1976); Museum Haus Lange, Krefeld, West Germany (1976); Musée National d'Art Moderne, Centre National d'Art et de Culture Georges Pompidou, Paris (1977); Sperone Westwater Fischer, New York (1978, 1980, 1983, 1985, 1987); Anna Leonowens Gallery, Nova Scotia College of Art and Design, Halifax (1978); Stedelijk Van Abbe Museum, Eindhoven, The Netherlands (1978, 1980); Whitechapel Art Gallery, London (1979); Galerie Isernhagen, Isernhagen, West Germany (1979); Konrad Fischer, Cologne (1981); Kunsthalle, Bielefeld, West Germany (1982, traveled to Kunstverein Mannheim, Mannheim, West Germany); Konrad Fischer, Zürich (1982); Musée d'Art et d'Industrie, St. Etienne, France (1984); Staatsgalerie Stuttgart, Stuttgart (1985); Marian Goodman Gallery, New York (1985, 1987); Galerie Jean Bernier, Athens (1985); Städtische Kunsthalle Düsseldorf, Düsseldorf (1986); Nationalgalerie, West Berlin (1986); Museum moderner Kunst, Vienna (1986); Kunsthalle Bern, Bern (1986); Art Gallery of Ontario, Toronto, and Museum of Contemporary Art, Chicago (1988, traveled to the Hirshhorn Museum and Sculpture Garden, Washington, D.C., 1988-89; San Francisco Museum of Modern Art, 1989); Anthony d'Offay Gallery, London (1988).

His group exhibitions include Lueg, Polke, Richter, Galerie Parnass, Wuppertal, West Germany (1964); Pop, etc., Galerie René Block, West Berlin (1964); Lueg, Polke, Richter, Galerie Orez, The Hague (1965); 14 Aspekte moderner Malerie, Haus der Kunst, Munich (1965); Nieuwe Figuratie, Museum Apeldoorn, Apeldoorn, The Netherlands (1965); La V Biennale de Paris, Musée d'Art Moderne de la Ville de Paris, Paris (1967); Neuer Realismus, Kunstverein Braunschweig, Braunschweig, West Germany (1967); Opening Exhibition, National Museum of Modern Art, Tokyo (1969); 9 Young Artists, Solomon R. Guggenheim Museum, New York (1969); Malerie nach Fotografie, Stadtmuseum München, Munich (1970); Strategy: Gets Art, International Festival, Edinburgh (1970); Kunst and Antikunst, Royal Scottish Academy of Painting, Sculpture and Architecture, Edinburgh (1970); New Multiple Art, Whitechapel Art Gallery, London (1971); Prospect '71, Städtische Kunsthalle Düsseldorf, Düsseldorf (1971); Documenta 5, Kassel, West Germany (1972); Prospect '73, Städtische Kunsthalle Düsseldorf, Düsseldorf (1973); Kunst aus Fotographie, Kunstverein Hannover, Hannover, West Germany (1973); Projekt—Aspekte der internationalen Kunst am Anfang der 70er Jahre, Kunsthalle Köln, Cologne (1974); Fundamentale Malerie, Stedelijk Museum, Amsterdam (1975); Europalia '77, 12 depuis 1945, Musées Royaux des Beaux-Arts, Brussels (1977); Europe in the Seventies: Aspects of Recent Art, The Art Institute of Chicago, Chicago (1977, traveled to Hirshhorn Museum and Sculpture

Garden, Washington, D.C.; San Francisco Museum of Modern Art, San Francisco; Modern Art Museum of Fort Worth, Fort Worth; The Contemporary Arts Center, Cincinnati); Documenta 6, Kassel, West Germany (1977); Beuys, Broodthaers, Buren, Kounellis, Merz, Richter, InK. Halle für Internationale Neue Kunst, Zürich (1978); Third Biennale of Sydney, Sydney (1979); XXXIX Biennale di Venezia, Venice (1980); Forms of Realism Today, Musée d'Art Contemporain, Montreal (1980); Der gekrummte Horizont. Kunst in Berlin 1945-1967, Akademie der Künste, West Berlin (1980); Art Allemagne Aujourd'hui, ARC, Musée d'Art Moderne de la Ville de Paris, Paris (1981); A New Spirit in Painting, Royal Academy of Arts, London (1981); Documenta 7, Kassel, West Germany (1982); Spiegelbilder, Wilhelm-Lehmbruck-Museum der Stadt Duisburg, Duisburg, West Germany (1982); 60'80, attitudes/concepts/images, Stedelijk Museum, Amsterdam (1982); Vier Perioden deutscher Malerei, Städtische Kunstmuseum Bonn, Bonn (1984); An International Survey of Recent Painting and Sculpture, The Museum of Modern Art, New York (1984); Ein anderes Klima, Städtische Kunsthalle Düsseldorf, Düsseldorf (1984); XLIV Biennale di Venezia, Venice (1984); The European Iceberg, Art Gallery of Ontario, Toronto (1985); La Nouvelle Biennale de Paris, Paris (1985); Deutsche Kunst seit 1960, Staatsgalerie moderner Kunst, Munich (1985); Carnegie International, Museum of Art, Carnegie Institute, Pittsburgh (1985); 1945-1985. Kunst in der Bundesrepublik Deutschland, Nationalgalerie, West Berlin (1985); German Art in the 20th Century, Royal Academy of Arts, London (1985, traveled to the Staatsgalerie Stuttgart, Stuttgart, 1986); The Mirror and the Lamp, The Fruitmarket Gallery, Edinburgh (1986, traveled to the Institute of Contemporary Arts, London); Avant-Garde in the Eighties, Los Angeles County Museum of Art, Los Angeles (1987); Implosion: A Postmodern Perspective, Moderna Museet, Stockholm (1987); The Image of Abstraction, The Museum of Contemporary Art, Los Angeles (1988).

SELECT BIBLIOGRAPHY

Anthony d'Offay Gallery. Gerhard Richter: The London Paintings. Exhibition catalogue. London: Anthony d'Offay Gallery, 1987.

Brougher, Kerry. The Image of Abstraction. Exhibition catalogue. Los Angeles: The Museum of Contemporary Art, 1988.

Nasgaard, Ronald. Gerhard Richter Paintings. Exhibition catalogue. New York: Thames and Hudson, 1987. Contains a select bibliography through 1987.

ANDRES SERRANO

Andres Serrano was born in New York City in 1950. He attended the Brooklyn Museum Art School from 1967 to 1969. He lives and works in Brooklyn.

His one-person exhibitions include those at Leonard Perlson Gallery, New York (1985); Museum of Contemporary Hispanic Art, New York (1985); Galerie Hufkens-Noirhomme, Brussels (1987); Stux Gallery, New York (1988); Greenberg-Wilson, New York (1988).

His group exhibitions include Timeline, a Group Material installation, P.S. 1, Long Island City, New York (1984); Indigestion, P.P.O.W., New York (1984); Americana, a Group Material installation at the Biennial Exhibition, Whitney Museum of American Art, New York (1985); Myth and History, Museum of Contemporary Hispanic Art, New York (1985); Funeral Rites, White Columns, New York (1985); Seeing Is Believing?, Alternative Museum, New York (1985); New New York, Cleveland Center For Contemporary Art, Cleveland (1986); Past, Present, Fu-

ture, The New Museum of Contemporary Art, New York (1986); *Fake*, The New Museum of Contemporary Art, New York (1987); *Scared to Breath*, Perspektief, Rotterdam (1987); *Floating Values*, Hallwalls, Buffalo (1987); *Documenta 8*, Kassel, West Germany (1987); *Myth/Ritual*, San Francisco Camerawork, San Francisco (1987); *The Spiral of Artificiality*, Hallwalls, Buffalo (1987); *Female (Re)Production*, White Columns, New York (1988); *New Surrealism*, Woodstock Center of Photography, Woodstock, New York (1988); *The Terrors and Pleasures in Living*, Kuhlenschmidt/Simon Gallery, Los Angeles (1988); *Awards in the Visual Arts 7*, Southeastern Center for Contemporary Art, Winston-Salem, North Carolina (1988, traveled to the Los Angeles County Museum of Art, Los Angeles; Carnegie-Mellon University Art Gallery, Pittsburgh; Virginia Museum of Fine Arts, Richmond).

SELECT BIBLIOGRAPHY
Bershad, Deborah. *The Spiral of Artificiality*. Exhibition catalogue. Buffalo: Hallwalls, 1987.
Cameron, Dan. "Ten to Watch." *Arts Magazine* 61 (September 1986): 40-65.
Kuspit, Donald. "Objects and Bodies: Ten Artists in Search of Interiority." *Awards in the Visual Arts 7*. Exhibition catalogue. Winston-Salem, North Carolina: Southeastern Center for Contemporary Art, 1988.
Lippard, Lucy. *Acts of Faith*. Exhibition catalogue. Cleveland: Cleveland State University Art Gallery, 1988.
Ludwig, Allan. *Seeing Is Believing?* Exhibition catalogue. New York: Alternative Museum, 1986.

HAIM STEINBACH

Haim Steinbach was born in Israel in 1944. He received a B.F.A. from the Pratt Institute, Brooklyn, in 1968 and a M.F.A. from Yale University in 1973. He lives and works in Brooklyn, New York.

His one-person exhibitions include those at Panoras Gallery, New York (1969); Yale University Art Gallery, New Haven (1973); Lamagna Gallery, New York (1975); Artists Space, New York (1979); Fashion Moda, Bronx (1980); Washington Project for the Arts, Washington, D.C. (1981, collaboration with Johanna Boyce; 1986); Concord Gallery, New York (1982); Graduate Center Mall, City University, New York (1983, collaboration with Julie Wachtel); Cable Gallery, New York (1985); Jay Gorney Modern Art, New York (1986, 1988); Sonnabend Gallery, New York (1987); Rhona Hoffman Gallery, Chicago (1987); Galleria Lia Rumma, Naples (1987); C.A.P.C., Musée d'Art Contemporain, Bordeaux (1988-1989).

His group exhibitions include *Survival Show*, Ninth Street, New York (1981); *Object, Structure, Artifice*, University of South Florida Art Galleries, Tampa, (1983, traveled to the Center Gallery of Bucknell University, Lewisburg, Pennsylvania); *Terminal New York, Preparing for War*, Brooklyn Army Terminal, Brooklyn (1983); *Timeline*, P.S. 1, Long Island City, New York (1984); *Objectivity*, Hallwalls, Buffalo (1984); *Infotainment*, Texas Gallery, Houston (1984, traveled to the Rhona Hoffman Gallery, Chicago; Vanguard Gallery, Philadelphia; The Aspen Art Museum, Aspen, Colorado); *Objects in Collision*, The Kitchen, New York (1984); *Cult and Decorum*, Tibor de Nagy, New York (1985); *Post Production*, Feature, Chicago (1985); *Time After Time*, Diane Brown Gallery, New York (1985); *Art and Its Double*, Fondació Caixa de Pensions, Barcelona and Madrid (1986); *Endgame*, Institute of Contemporary Art, Boston (1986); *The Brokerage of Desire*, Otis Art Institute, Los Angeles (1986); *Rooted Rhetoric*, Castelle dell'Ovo, Naples (1986); *Damaged Goods*, The New Mu-

seum of Contemporary Art, New York (1986); *The Color Red*, Massimo Audiello, New York (1986); *New Sculpture*, The Renaissance Society at the University of Chicago, Chicago (1986); *Post Pop Art*, Michael Kohn Gallery, Los Angeles (1986); *Currents 12: Simulations, New American Conceptualism*, Milwaukee Art Museum, Milwaukee (1987); *New York Now*, The Israel Museum, Jerusalem (1987); *Avant-Garde in the Eighties*, Los Angeles County Museum of Art, Los Angeles (1987); *Les Courtiers du Desire*, Centre National d'Art et de Culture Georges Pompidou, Paris (1987); *Extreme Order*, Galleria Lia Rumma, Naples (1987); *Romance*, Knight Gallery, Spirit Square Center for the Arts, Charlotte, North Carolina (1987); *Documenta 8*, Kassel, West Germany (1987); *NY Art Now: The Saatchi Collection*, The Saatchi Collection, London (1987); *Primary Structures*, Rhona Hoffman Gallery, Chicago (1987); *Cultural Geometry*, The Deste Foundation for Contemporary Art, Deka House of Cyprus, Athens (1988); *Broken Neon*, Galerie Durr, Munich (1988); *New York in View*, Müncher Kunstverein, Munich (1988); *The Pop Project: Part IV, Nostalgia as Resistance*, Clocktower, New York (1988); *Art at the End of the Social*, Rooseum, Malmö, Sweden (1988); *American Art of the Late '80s: The Binational*, Museum of Fine Arts, Boston, and Institute of Contemporary Art, Boston (1988, traveled to Kunsthalle Düsseldorf, Kunstsammlung Nordrhein-Westfalen, Kunstverein für die Rheinlande und Westfalen, Düsseldorf, 1989); *Innovations in Sculpture 1985-1988*, The Aldrich Museum of Contemporary Art, Ridgefield, Connecticut (1988); *New Urban Landscape*, The World Financial Center, New York (1988).

SELECT BIBLIOGRAPHY
C.A.P.C., Musée d'Art Contemporain. *Haim Steinbach*. Exhibition catalogue. Bordeaux, France: C.A.P.C., Musée d'Art Contemporain, 1988. Contains a select bibliography through 1988.

PHILIP TAAFFE

Philip Taaffe was born in Elizabeth, New Jersey, in 1955. He lives and works in New York.

His one-person exhibitions include Galerie Ascan Crone, Hamburg (1984, 1986); Pat Hearn Gallery, New York (1984, 1986, 1987); Mario Diacono Gallery, Boston (1987); Donald Young Gallery, Chicago (1988).

His group exhibitions include *Turn It Over*, sponsored by White Columns at the studio of Sandro Chia, New York (1983); *Sex*, Cable Gallery, New York (1984); *Paravision*, Postmasters Gallery, New York (1985); *Post Style*, Wolff Gallery, New York (1985); *Vernacular Abstraction*, Wacoal Art Center, Tokyo (1985); *A Brave New World, A New Generation*, Charlottenborg Exhibition Hall, Copenhagen (1985); *Primer Salon Irrealista*, Galerie Leyendecker, Santa Cruz de Tenerife, Spain (1985); *Geometrie, Abstraction, Ornament*, Galerie Nacht St. Stephan, Vienna (1985); *Sixth Biennale of Sydney*, Sydney (1986); *The Science of Painting*, Metro Pictures, New York (1986); *The Red Show*, Massimo Audiello Gallery, New York (1986); *Tableaux Abstraits*, Centre National d'Art Contemporain, Nice (1986); *Endgame*, Institute of Contemporary Art, Boston (1986); *Art and Its Double*, Fondació Caixa de Pensions, Barcelona and Madrid (1986); *Prospect '86*, Kunstverein, Frankfurt (1986); *Biennial Exhibition*, Whitney Museum of American Art, New York (1987); *Post Abstract Abstraction*, The Aldrich Museum of Contemporary Art, Ridgefield, Connecticut (1987); *Similia/Dissimila*, Kunsthalle Düsseldorf, Düsseldorf (1987, traveled to Wallach Art Gallery, Columbia University; Leo Castelli Gallery; and Sonna-

bend Gallery, New York); *Recent Tendencies in Black and White*, Sidney Janis Gallery, New York (1987); *The New Poverty*, John Weber Gallery, New York (1987); *NY Art Now: The Saatchi Collection*, The Saatchi Collection, London (1987); *Primary Structures*, Rhona Hoffman Gallery, Chicago (1987); *Rot Gelb Blau: Die Primarfarben in der Kunst des 20. Jahrhunderts*, Kunstmuseum St. Gallen, St. Gallen, Switzerland (1988).

SELECT BIBLIOGRAPHY

Bois, Yve-Alain, Thomas Crow, Hal Foster, David Joselit, Bob Riley, and Elisabeth Sussman. *Endgame: Reference and Simulation in Recent Painting and Sculpture*. Exhibition catalogue. Cambridge, Massachusetts: MIT Press, 1986.

Burgi, Bernhard. *Rot Gelb Blau: Die Primarfarben in der Kunst des 20. Jahrhunderts*. Exhibition catalogue. St. Gallen, Switzerland: Kunstmuseum St. Gallen, 1988.

Bleckner, Ross. *Philip Taaffe*. Exhibition catalogue. New York: Pat Hearn Gallery, 1986.

Cameron, Dan. "The Other Philip Taaffe." *Arts Magazine* 60 (October 1985): 18-20.

_____. *Art and Its Double: Recent Tendencies in New York Art*. Exhibition catalogue. Barcelona: Fondació Caixa de Pensions, 1986.

_____. *NY Art Now: The Saatchi Collection*. Exhibition catalogue. N.p.: Giancarlo Politi Editore, n.d.

Cortez, Diego. *Philip Taaffe*. Exhibition catalogue. Hamburg: Galerie Ascan Crone, 1986.

Foster, Hal. "Signs Taken for Wonders." *Art in America* 74 (June 1986): 80-91.

Kuspit, Donald. "Young Necrophiliacs, Old Narcissists: Art about the Death of Art." *Artscribe* 57 (April 1986): 27-31.

Liebmann, Lisa. "M.B.A. Abstraction." *Flash Art* 132 (February/March 1987): 86-89.

McCormick, Carlo. "Poptometry." *Artforum* 24 (November 1985): 87-91.

McEvilley, Thomas. "Marginalia: On Son of Sublime." *Artforum* 26 (May 1988): 11-12.

Pincus-Witten, Robert. "Entries: The Scene that Turned on a Dime." *Arts Magazine* 60 (April 1986): 20-21.

_____. "Electrostatic Cling." *Artscribe* 64 (Summer 1987): 36-41.

Siegel, Jeanne. Exhibition review of Philip Taaffe. *Flash Art* 127 (April 1986): 68-69.

Smith, Roberta. *Vernacular Abstraction*. Exhibition catalogue. Tokyo: Wacoal Art Center, 1985.

ROSEMARIE TROCKEL

Rosemarie Trockel was born in Schwerte, West Germany, in 1952. She lives and works in Cologne.

Her one-person exhibitions include those at Monika Sprüth Galerie, Cologne (1983, 1984, 1986); Galerie Magers, Bonn (1983); Galerie Ascan Crone, Hamburg (1984, 1987); Galerie Stampa, Basel (1984); Rheinisches Landesmuseum, Bonn (1985); Galerie Skulima, Berlin (1985); Galerie Friedrich, Bern (1986); Galerie Tanit, Munich (1987); The Museum of Modern Art, New York (1988); Barbara Gladstone Gallery, New York (1988). She had a two-person exhibition with Katarina Fritsch at the Kunsthalle Basel, Basel, and Institute of Contemporary Arts, London (1988).

Her group exhibitions include *Licht bricht sich in den oberen Fenstern*, Im Klapperhof 33, Cologne (1982); *Bella Figura*, Wilhelm-Lehmbruck-Museum der Stadt Duisburg, Duisburg, West Germany (1984, traveled to Museum Van Bommel-Van-Dam, Venlo, The Netherlands; *Kunst mit Eigen-Sinn*, Museum moderner Kunst, Vienna (1985); *Herbstsalon*, Museum Ludwig, Cologne (1985); *Primer Salon Irrealista*, Galeria Leyendecker, Santa Cruz de Tenerife, Spain (1986); *Sixth Biennale of Sydney*, Sydney (1986); *Hacen lo que quieren*, Museo de Arte Contemporaneo de Sevilla, Seville, Spain (1987); *Art from Europe*, Tate Gallery, London (1987); New York (1986); *Similia/Dissim-ilia*, Städtische Kunsthalle Düsseldorf, Düsseldorf (1987, traveled to Wallach Art Gallery, Columbia University; Leo Castelli Gallery; and Sonnabend Gallery, New York); *Comic Iconoclasm*, Institute of Contemporary Arts, London (1987); *Media Post Media*, Scott Hanson Gallery, New York (1988); *German Art of the Late '80s: The Binational*, Städtische Kunsthalle Düsseldorf, Kunstsammlung Nordrhein-Westfalen, Kunstverein für die Rheinlande und Westfalen, Düsseldorf (1988, traveled to the Museum of Fine Arts, Boston, and Institute of Contemporary Art, Boston, 1989); *1988 Carnegie International*, The Carnegie Museum of Art, Pittsburgh (1988-89).

SELECT BIBLIOGRAPHY

Galeria Leyendecker, Santa Cruz de Tenerife. *Primer Salon Irrealista*. Exhibition catalogue. Santa Cruz de Tenerife, Spain: Galeria Leyendecker, 1986.

Im Klapperhof 33. *Licht bricht sich in den oberen Fenstern*. Exhibition catalogue. Cologne: Im Klapperhof 33, 1982.

Institute of Contemporary Arts, London. *Comic Iconoclasm*. Exhibition catalogue. London: Institute of Contemporary Arts, 1987.

Koether, Jutta. "The Resistant Art of Rosemarie Trockel." *Artscribe* 62 (March/April 1987): 54-55.

Leigh, Christian. "Rosemarie Trockel." *Artforum* 26 (Summer 1988): 135-36.

Rheinisches Landesmuseum Bonn, Bonn. *Rosemarie Trockel, Arbeiten 1980-1985*. Exhibition catalogue. Cologne: Rheinland Verlag GmbH, 1985.

Salvioni, Daniela. "Spotlight: Trockel and Fritsch." *Flash Art* 140 (May/June 1988): 110.

Städtische Kunsthalle Düsseldorf, Düsseldorf. *Similia/Dissimilia*. Düsseldorf: Städtische Kunsthalle Düsseldorf, 1987.

Vesterl, Karl-Egon, ed. *Bella Figura*. Exhibition catalogue. Duisburg, West Germany: Wilhelm-Lehmbruck-Museum der Stadt Duisburg, 1984.

WALLACE & DONOHUE

Wallace & Donohue were born in 1959 and attended the Hartford Art School in Hartford, Connecticut.

Their "one-person" exhibitions include The New Museum of Contemporary Art, New York (1985); Postmasters Gallery, New York (1986, 1988); Tony Shafrazi Gallery, New York (1987); Real Art Waves Gallery, Hartford, Connecticut (1988); John Weber Gallery, New York (1989).

Their group exhibitions include *Look Where We Are*, Hartford Art School Gallery, Hartford, Connecticut (1981); *Turn It Over*, sponsored by White Columns at the studio of Sandro Chia, New York (1983); *Cave Painting* and *Exposed*, both at Bedrock, Brooklyn (1984); *Final Love*, Cash/Newhouse, New York (1985); *Paravision*, Postmasters Gallery, New York (1985); *Spiritual America*, CEPA Gallery, Buffalo (1986); *Paravision II*, Margo Leavin, Los Angeles (1986); *Reconstruct*, John Gibson Gallery, New York (1987); *The Art of the Real*, Galerie Pierre Huber, Geneva (1987, traveled to the Appel Foundation, Amsterdam); *Europa/America-Nuovi Territori dell' Arte*, Fondazione Michetti, Francavilla al Mare, Italy (1987); *Primary Structures*, Rhona Hoffman, Chicago (1987); *Cultural Geometry*, The Deste Foundation for Contemporary Art, Deka House of Cyprus, Athens (1988); *Works. Concepts. Processes. Situations. Information*, Galerie Hans Mayer, Düsseldorf (1988); *Color Alone: The Monochrome Experiment*, Musée St. Pierre, Lyon, France (1988).

SELECT BIBLIOGRAPHY

Bankowsky, Jack. Exhibition review of Wallace & Donohue. *Flash Art* 133 (April 1987): 91.

_____, and Robert Nikas. *Works. Concepts. Processes. Situations. Information*. Exhibition catalogue. Düsseldorf: Galerie Hans Mayer, 1988.

Cameron, Dan. "Seven Types of Criticality." *Arts Magazine* 61 (May 1987): 14-17.

Cooper, Dennis. Exhibition review of Wallace & Donohue. *Flash Art* 26 (April 1988): 142.

Deitch, Jeffrey. *Cultural Geometry*. Exhibition catalogue. Athens: The Deste Foundation for Contemporary Art, 1988.

Nikas, Robert. *Primary Structures*. Exhibition catalogue. Chicago: Rhona Hoffman Gallery, 1987.

_____. *The Art of the Real*. Geneva: Galerie Pierre Huber, 1987.

_____. *Color Alone: The Monochrome Experiment*. Exhibition catalogue. Lyon: Musée St. Pierre, 1988.

Saltz, Jerry. *Beyond Boundaries: New York's New Art*. New York: Alfred van der Marck, 1986.

Smith, Roberta. Exhibition review of Wallace & Donohue. *New York Times*, October 31, 1986.

_____. Exhibition review of Wallace & Donohue. *New York Times*, February 26, 1988.

Wei, Lilly. "Talking Abstract, Part Two." *Art in America* 65 (September/October 1987): 79-80.

TERRY WINTERS

Terry Winters was born in Brooklyn in 1949. He received a B.F.A. from the Pratt Institute, New York, in 1971. He lives and works in New York.

His one-person exhibitions include those at Sonnabend Gallery, New York (1982, 1984, 1986, 1987); Galerie Jean Bernier, Athens (1983, with Carroll Dunham); Reed College, Portland, Oregon (1983); Daniel Weinberg Gallery, Los Angeles (1984); Kunstmuseum Luzern, Lucerne (1985); Castelli Graphics, New York (1986); Tate Gallery, London (1986); Barbara Krakow Gallery, Boston (1986); The Saint Louis Art Museum, St. Louis (1987); Daniel Weinberg Gallery, Los Angeles (1987); Walker Art Center, Minneapolis (1987); Museum of Fine Arts, Boston (1987); Mario Diacono Gallery, Boston (1987); Massachusetts Institute of Technology, Cambridge (1987); University Art Museum, University of California, Santa Barbara (1987); Galerie Max Hetzler, Cologne (1988).

His group exhibitions include *A Painting Show*, P.S. 1, Long Island City, New York (1977); *Summer/77*, Drawing Center, New York (1977); *Committed to Paint*, Delahunty Gallery, Dallas (1981); *New Image*, The Baltimore Museum of Art, Baltimore (1982); *New Drawing in America*, Drawing Center, New York (1982); *A Painting Exhibition*, Paula Cooper Gallery, New York (1983); *Affinities*, Hayden Gallery, Massachusetts Institute of Technology, Cambridge (1983); *New Art*, Tate Gallery, London (1983); *The American Artist as Printmaker*, The Brooklyn Museum, Brooklyn (1983); *New York Now—Works on Paper*, Nordjyllands Kunstmuseum, Aalborg, Denmark (1983); *The Meditative Surface*, The Renaissance Society at the University of Chicago, Chicago (1984); *An International Survey of Recent Painting and Sculpture*, The Museum of Modern Art, New York (1984); *Drawings: Contemporary Installation*, The Museum of Modern Art, New York (1984); *Biennial Exhibition*, Whitney Museum of American Art, New York (1985, 1987); *Vernacular Abstraction*, Wacoal Art Center, Tokyo (1985); *Three Printmakers: Jennifer Bartlett, Susan Rothenberg, Terry Winters*, Whitney Museum of American Art, New York (1986); *Public and Private—American Prints Today*, The Brooklyn Museum, Brooklyn (1986); *An American Renaissance: American Painting and Sculpture since 1940*, Museum of Art, Fort Lauderdale, Florida (1986); *Monumental Drawings, Works by 22 Contemporary Americans*, The Brooklyn Museum, Brooklyn (1986); *Europe/America*, Museum Ludwig, Cologne (1986); *40th Biennial of Contemporary American Painting*, The Corcoran Gallery of Art, Washington, D.C. (1987); *Drawings from the Eighties*, Carnegie-Mellon University Art Gallery, Pittsburgh (1987); *Edinburgh International: Reason and Emotion in Contemporary Art*, Royal Society of Edinburgh, Edinburgh (1987); *Vital Signs: Organic Abstraction from the Permanent Collection*, Whitney Museum of American Art, New York (1988).

SELECT BIBLIOGRAPHY

Farmer, J. David, Christopher Knight, and Phyllis Plous. *Terry Winters: Paintings and Drawings*. Exhibition catalogue. Santa Barbara: University Art Museum, Santa Barbara, 1987. Contains a bibliography through 1987.

Kertess, Klaus, and Martin Kunz. *Terry Winters*. Exhibition catalogue. Lucerne: Kunstmuseum Luzern, 1985.

CHRISTOPHER WOOL

Christopher Wool was born in 1955. He does not want any other background information about his life to be published, according to the Luhring Augustine Gallery, New York, which currently represents him.

His one-person exhibitions include those at Cable Gallery (1984, 1986); Robbin Lockett Gallery, Chicago (1986); Luhring, Augustine & Hodes Gallery, New York (1987, 1988); Galerie Jean Bernier, Athens (1988).

His group exhibitions include an untitled show, White Columns, New York (1982); *Big American Figure Drawings*, Visual Arts Museum, New York (1983); *Selected Drawings*, Jersey City Museum, Jersey City (1983); *Abbott, Fink, Lieber, Wool*, Delahunty Gallery, New York (1983); *Sex*, Cable Gallery, New York (1984); *The Hidden Surface*, Middendorf Gallery, Washington, D.C. (1986); *Signs of Painting*, Donald Young Gallery, Chicago (1986); *Fortuyn/O'Brien, Lemieux, Mullican, Wool*, Luhring, Augustine & Hodes Gallery, New York (1986); *Painting, Abstraction Rediscovered*, Rosa Esman Gallery, New York (1986); *Europa/America-Nuovi Territori dell' Arte*, Fondazione Michetti, Francavilla al Mare, Italy (1987); *Johnson, Tasset, Wool*, Kuhlenschmidt/Simon, Los Angeles (1987); *Industrial Icons*, University Art Gallery, San Diego State University, San Diego (1987); *Robert Gober and Christopher Wool*, 303 Gallery, New York (1988); *Six Americans: Bleckner, Halley, Levine, Taaffe, Wool, Welling*, Galerie Lelong, New York (1988); *Een Keuze/A Choice*, Kunst Rai, Amsterdam (1988); *Information as Ornament*, Feature, Chicago (1988); *The Light from the Other Side*, Monika Sprüth Galerie, Cologne (1988).

SELECT BIBLIOGRAPHY

Bulka, Michael. "Christopher Wool." *New Art Examiner* 13 (Summer 1986): 45.

Cameron, Dan. "In the Realm of the Hyper-Abstract." *Arts Magazine* 61 (November 1986): 36.

Lurie, David. Exhibition review of Christopher Wool. *Arts Magazine* 60 (April 1986): 133.

Saltz, Jerry. *Beyond Boundaries, New York's New Art*. New York: Alfred van der Marck, 1987.

Westerbeck, Colin. Exhibition review of Christopher Wool. *Artforum* 25 (September 1986): 139.